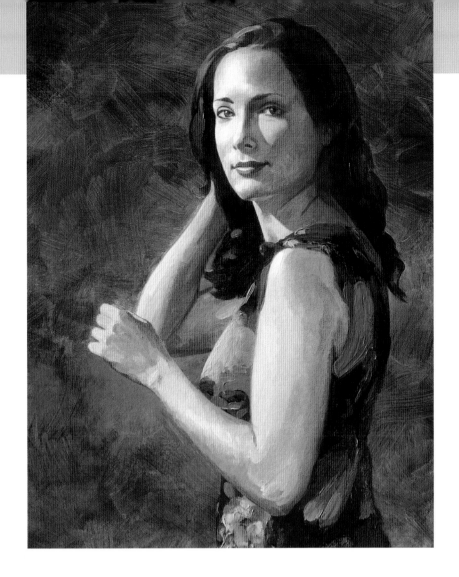

bold
strokes

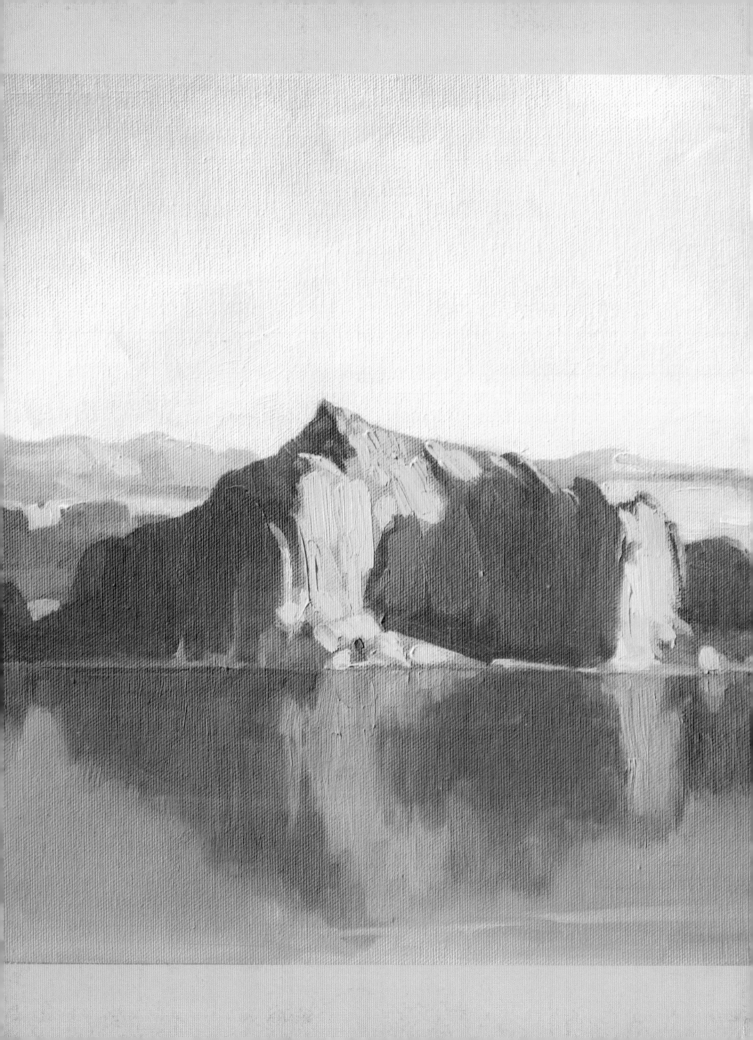

bold
strokes

dynamic **brushwork** for **oils** and **acrylics**

Mark Christopher Weber

WITHDRAWN

NORTH LIGHT BOOKS
CINCINNATI, OHIO
www.artistsnetwork.com

Bold Strokes: Dynamic Brushwork for Oils and Acrylics. Copyright © 2009 by Mark Christopher Weber. Printed in Singapore. All rights reserved. No part of this book may be reproduced in any form or by any electronic or mechanical means including information storage and retrieval systems without permission in writing from the publisher, except by a reviewer who may quote brief passages in a review. Published by North Light Books, an imprint of F+W Publications,

fw
F+W PUBLICATIONS, INC.

Inc., 4700 East Galbraith Road, Cincinnati, Ohio, 45236. (800) 289-0963. First Edition.

Other fine North Light Books are available from your local bookstore, art supply store, online supplier or visit our website at www.fwpublications.com.

13 12 11 10 09 5 4 3 2 1

Distributed in Canada by Fraser Direct
100 Armstrong Avenue
Georgetown, ON, Canada L7G 5S4
Tel: (905) 877-4411

Distributed in the U.K. and Europe by David & Charles
Brunel House, Newton Abbot, Devon, TQ12 4PU, England
Tel: (+44) 1626 323200, Fax: (+44) 1626 323319
Email: postmaster@davidandcharles.co.uk

Distributed in Australia by Capricorn Link
P.O. Box 704, S. Windsor NSW, 2756 Australia
Tel: (02) 4577-3555

Library of Congress Cataloging-in-Publication Data
Weber, Mark Christopher
 Bold strokes : dynamic brushwork for oils and acrylics / Mark Christopher Weber.
 p. cm.
 Includes index.
 ISBN-13: 978-1-60061-067-7 (hardcover : alk. paper)
 1. Brushwork. 2. Painting--Technique. I. Title.
 ND1505.W428 2009
 751.45--dc22 2008034159

Edited by Vanessa Lyman and Erika O'Connell
Interior designed by Amy Wilkin
Cover designed by Guy Kelly
Production coordinated by Matt Wagner

art from the cover:
Hillside Tree
Acrylic on canvas on panel
24" × 18" (61cm × 46cm)

art on the previous two pages:
Lake Powell Formation
Oil on canvas on panel
20" × 24" (51cm × 61cm)

metric conversion chart

to convert	to	multiply by
inches	centimeters	2.54
centimeters	inches	0.4
feet	centimeters	30.5
centimeters	feet	0.03
yards	meters	0.9
meters	yards	1.1

about the author

Mark Christopher Weber was born in 1949 in Cleveland, Ohio. From his earliest years, he was enthralled by modeling with clay and drawing. Eventually he turned to painting and studied under Donald Roller Wilson at the University of Arkansas, where he graduated in 1972 with a bachelor of arts degree.

In 1979 he married Randi Zeinfeld, who became his irreplaceable partner in the art business and the loving mother of his five wonderful and unique kids. Over the years, the joys and challenges of family, art and life have served to deepen his experience of God's grace and peace.

Mark has won many awards for his paintings, and his work hangs in private and corporate collections. A list of these as well as galleries that carry his work can be found on his website at www.MarkWeberArtist.com.

As Mark mastered his craft, he began to feel a need to "pass on what he knew before he passed on." He became an author and a teacher, writing and illustrating his first book, *Brushwork Essentials* (North Light Books), which has helped and inspired countless artists through its clear and practical instruction. Shortly after completing the book, Mark decided to expand his own painting horizons by using bolder brushstrokes, more vivid color, and even incorporating some abstraction. Not long after, the idea for *Bold Strokes* was born.

In addition to writing, Mark is currently teaching painting classes in his studio in Kansas City where he and his wife live. His teaching will soon fly under the banner of the Weber School of Fine Art in Kansas City, a two-year painting school for artists who want to learn the traditional skills of painting in a representational style.

▼ **Mountain Pass**
Oil on canvas
18" × 32" (46cm × 81cm)

dedication

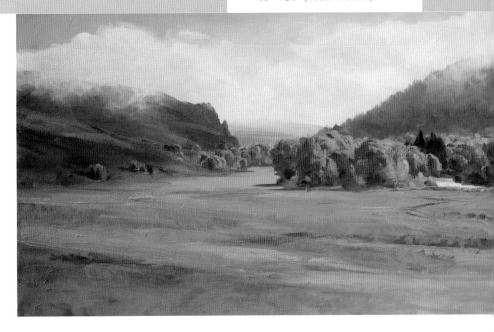

I've been blessed to have many wonderful students who share my passion for art and life. They made me write this book, and I dedicate it to them and their joy.

acknowledgments

An endeavor like this is never accomplished in a vacuum, and I have a host of folks who made it possible to craft this book.

At the top of the list is my remarkable wife, Randi, who did a yeowoman's job laboring for endless hours doing all the computer whiz-bang manipulation to get the images from camera to editor in the correct format and order.

Of the many good people at North Light Books, I especially want to thank my editors, Vanessa Lyman and Erika O'Connell, who patiently shepherded me through a whole slew of issues and put it all together, and Jamie Markle, who saw the merit in my original concept and got the ball rolling.

My thanks to Timothy Hopper of Holbein® and Scott Present of Liquitex® for generously supplying the top-quality paints used to create the artwork for this book, and John

Weber of Silver Brush Limited® for graciously providing high-quality brushes for the task.

Photographer Michael Spillers helped big-time in guiding me through some daunting digital camera issues, as did Terry Weckbaugh of ImageQuest.

My daughter Zephra also pitched in with her expertise at a critical juncture and provided photos for a couple paintings of scenes in Italy.

Then we have Bill Deacon, Valda Hsu, Whitney Hiebert, Talaessa Bice, Mark Wayne, Francie Costello and Madhi Almadhi—my friends who modeled for several of the paintings. They've earned my hearty appreciation for putting up with a lot of "Rotate your shoulders to the right just a teensy bit. Lower your left hand. Brush your hair back and give me that Mona Lisa smile. Now raise your chin a tad," and on and on. Good work, folks.

I also want to thank The Culture House for use of its facility for one of the modeling sessions.

Thanks to those of you who contacted me during the writing process with words of appreciation for my first book, *Brushwork Essentials*. Your words buoyed my spirits when I was struggling with the toughest parts and contemplating packing it in.

If there are others I've forgotten in the rush and tumble of meeting deadlines and pushing my way through the fog of organizing all the disparate elements of the book, I like you, too.

Last but not least, I give many thanks to my students who share my love for art and laugh at my jokes—or is it me they're laughing at? We may never know.

contents

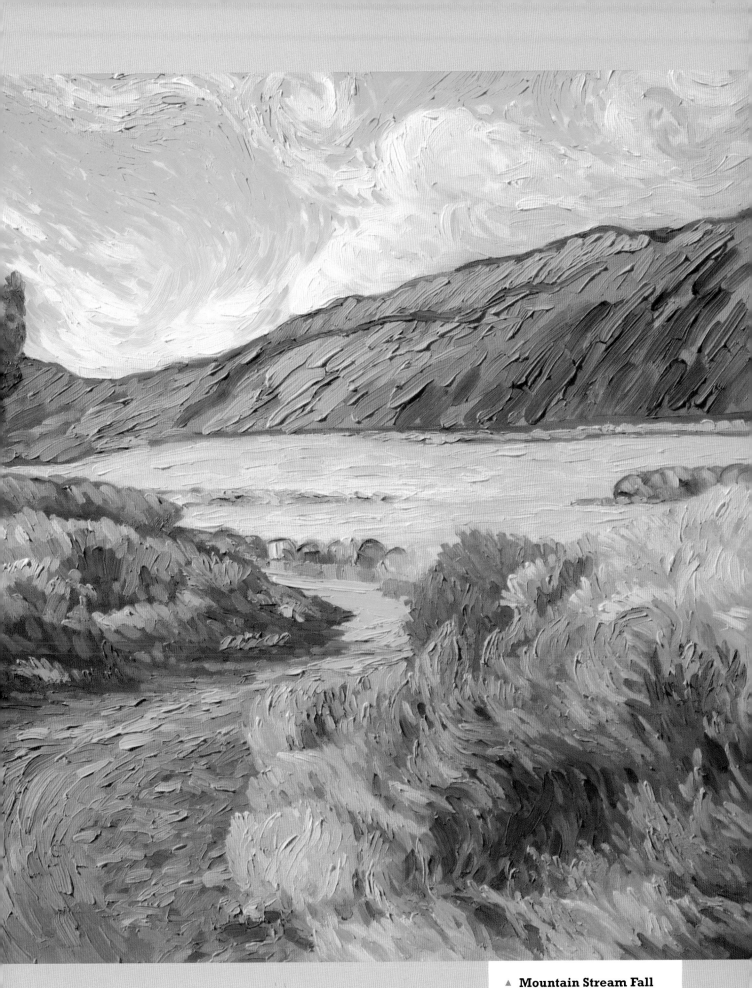

▲ **Mountain Stream Fall**
Oil on canvas on panel
20" × 24" (51cm × 61cm)

▲ **Sunset Glow**
Acrylic on canvas
11" × 14" (28cm × 36cm)

We've all been captivated by bold, thick brushwork in paintings. We're dazzled by the raw vitality and seemingly abstract, even random, application of fluid strokes and chunky globs of paint that, when viewed from a few steps away, resolve into a realistic image pulsing with energy, color and life.

We yearn to experience that exhilarating sense of creative freedom through our own art. Yet if you have struggled to master this apparently spontaneous and effortless style, you've probably discovered that it's a lot more difficult to do than it appears. The typical experience for folks attempting this technique goes something like this:

You love the bravura brushwork of Sargent, Sorolla and a host of other masters, and, determined to incorporate it into your paintings, you prepare your canvas, paints and brushes and enthusiastically plunge ahead. You lay down a series of thick, juicy strokes, but the color or value isn't quite right, so you add a little of this or that, still applying the paint generously. Unsatisfied with the result, you pile on more strokes—and clench your teeth, because it's still not what you envisioned. You feel compelled to lay on even more paint, but the more you labor, the more unruly the mess on your canvas becomes, zapping the last of your initial inspiration. In the end, you slump into a chair and glower at the disaster on your easel: "What is the big secret to doing this? I don't get it!"

introduction

First you must confront a couple of fallacies:

1. Many of us unconsciously believe that it's possible through sheer passion to switch on some mysterious creative capacity in our brains and—presto!—out flows brilliant impasto brushwork infusing our paintings with boldness.

2. Then there's the "happy accident" misconception: If you keep slapping on paint and randomly flopping your brush around, something special is bound to happen. Happy accidents are only slightly more common in brushwork than they are on the highway. Knowledge and skill are essential to good results.

It's time to abandon the Sling, Smear and Hope Method to Freeing Your Inner Genius, which has failed dismally, and take up the analytical and disciplined approach of study, practice, plan and paint.

Bold Strokes provides clear instruction and simple exercises for you to explore bold, thick brushwork applications for your art. At its core is a simple concept:

Limit the number of bold strokes to make you think about and carefully design them until it becomes second nature.

In order to prepare you for the exercises in Chapter Five, the first four chapters will teach you:

- How to select the appropriate brushes, paints and other materials.
- Basic brushwork techniques.
- Specific principles, skills and attitudes to equip your mind for the loose, bold painting style.

As you assimilate this background material, the new methods and possibilities will become clearer. The more skilled you become, the more "happy accidents" you'll have.

1 am fascinated that human beings can take the simplest, most primitive tools—charred vines, colored paste, hair-tipped sticks, rocks, metal points and hammers—and create with them works of stunning beauty overflowing with profoundly moving expressions of human life. It's an amazing gift to be able to take thoughts from the depths of our spirits and translate them directly through our fingers into art-works that bring joy, peace, renewal and grace to people's lives.

materials
CHAPTER 1

That's what my romantic side thinks. My practical side appreciates painting as a low-overhead operation with limitless possibilities. Whatever side motivates you, a solid understanding of your tools and materials is necessary to making lasting and pleasing art.

You've heard the saying, "You're only as good as your tools." Since I'd choose Sargent, Cassatt or Rembrandt wielding a worn paint roller over any lesser artist with the finest equipment, I don't really subscribe to that maxim. However, it is true that using the right brushes, paints and supports can make a world of difference in the ease and enjoyment of painting, the range of effects you can achieve and the durability of the finished work of art. In a brief book like this, I can only touch on the basic facts that are relevant to the pursuit of bold brushwork, but fortunately there is an astounding amount of information available about all the materials and their uses, so read and ask questions of knowledgeable people to expand your understanding and improve your art.

◄ **Petra Tomb**
Acrylic on linen
30" × 24" (76cm × 61cm)

oil paints

Although very similar-looking dynamic painting effects can be achieved with both oils and acrylics, we'll cover them individually to address their distinct advantages and disadvantages because of the major differences between the characteristics of the two media.

Traditional Oils

Oil paints are the premier medium for creating bold brushwork. Their thick, non-shrinking consistency allows you to lay on juicy mounds of pigment, and their slow drying time makes it possible to work in a leisurely fashion for easy, wet-into-wet blending.

The slow drying time of oils is a double-edged sword, however, because you must often wait days for wet paint to dry before you can work over it. And before you can apply your final varnish, it's advisable to allow oils to dry a minimum of six months; if the paint is especially thick, you'll want to let it dry months longer.

Perhaps the most demanding characteristic of oils involves the nature of its linseed oil binder. For starters, linseed oil tends to yellow slightly with age, as does Damar varnish, a common ingredient in oil painting mediums.

If you choose to paint in more than one layer, things become more complicated. To insure proper bonding of multiple layers, the paint of each new layer must contain proportionally more oil than the previous one. This is called the fat-over-lean rule. Failure to follow this principle can result in the paint cracking, chipping, splitting, pealing or turning to powder.

Even with the most careful preparations, oil paintings still tend to crack with age. That's just the nature of the medium. And the thicker the paint, the more likely it is to crack. The amount of extra oil you need to add to each new coat is actually quite small, but it's important to add that little bit extra to all the paint you mix.

For loose paintings, I usually apply only one coat of paint and will add oil only to make the pigment more fluid. For more carefully rendered works, I'll do two coats, occasionally adding glazes in areas as a third layer.

Water-Soluble Oils

If you're sold on oils but want to avoid toxic fumes, water-soluble oils are a wonderful alternative. Some brilliant researchers have modified the chemistry of linseed oil, enabling the paints to thin with water.

Other than being able to rinse your brushes with water to remove paint and thinning the pigment with water to create washes, water-soluble oils function in

Linseed Oil

Linseed oil has three primary uses in oil painting:
1. *Make the paint more fluid.*
2. *Insure proper bonding of multiple paint layers.*
3. *Create translucent glazes.*

▶ toxic solvents

Thinning traditional oils or rinsing paint from brushes requires the use of solvents like turpentine, mineral spirits and petroleum distillates. These products give off toxic fumes, which, when breathed in, are absorbed by the blood and affect the liver, kidneys and other organs.

Getting solvents on your hands is equally dangerous because the volatile spirits pass directly through your skin into the blood stream. If you choose to use these materials, work in a well-ventilated area and keep your hands out of the solvents.

12

all other ways like traditional oils. Since I can get the same results with both kinds, it makes sense to me to go with the healthier product.

There are several different brands of water-soluble oils with varying characteristics. Whenever a new brand comes on the market, I buy a few tubes and test them. So far I haven't found anything that comes close to Holbein Duo Aqua Oil paints. They handle like a dream, and they thin wonderfully with water, making it easy to create washes for the early painting stage.

For the oil exercises in this book, I've painted exclusively with water-soluble oils, but you can use traditional oils and solvents if you choose.

My Water-Soluble Oil Palette of Colors
My palette has changed a bit since **Brush-work Essentials.** *On top of that, Holbein has recently added colors to its list and changed the names of some of the older ones. The colors I use most often are Burnt Sienna, Cadmium Red Hue, Cadmium Yellow Hue, Cadmium Yellow Light Hue, Dioxazine Violet, Naples Yellow, Payne's Grey, Phthalo Blue, Raw Umber, Rose Madder, Titanium White, Ultramarine Light and Yellow Ochre. For medium I use Holbein Duo Aqua Oil Linseed Oil.*

to thin or not to thin with water

Thin the pigment with water only at the very first stage of a painting. In keeping with the fat-over-lean principle, never apply a layer of water-thinned paint over a dry layer of oil paint.

acrylic paints

Although acrylics are vastly different from oils, it's possible to achieve many of the same impasto effects with them. You can also use acrylic gel and textural mediums to create amazing effects not possible (or at least not advisable) with oils.

Much of choosing one medium over the other comes down to personal preference because of the different handling properties of the two. I work with acrylics as much as I do with oils, and I try to exploit their respective advantages.

Acrylic Mediums

The consistency of acrylics can be adjusted by adding water as well as by mixing in additives such as glazing medium, thinning and thickening gels, gloss and matte gels, iridescent medium, modeling paste and retarders. The texture can be altered by adding ceramic stucco, string gel, pumice gel and other textural mediums. Read the instructions on these products before trying them, and then experiment to see how each particular medium will affect the paint.

Shrinkage

Because acrylics are water-based, they dry by evaporation. When the water disappears, the paint body actually shrinks. You might paint an area with what you think are hefty amounts of pigment, expecting the dried brushwork to show up a certain way, and then the strokes will all but disappear upon drying.

On top of that, once the paint dries, the grooves created by the brush hairs become rounded in appearance, which reduces the crispness of the strokes.

Modeling Paste

Modeling paste shrinks less than acrylics do. It can be brushed or applied with a palette knife directly onto the canvas to create a heavily textured surface, and then painted over after it dries. It can also be mixed in with acrylics to reduce shrinkage and create a matte finish.

As useful as modeling paste is, it should be added to paint in moderation because of the following liabilities:

- It reduces the intensity of colors, making them appear chalky.
- It increases drying speed.
- It makes the paint film brittle.

My Acrylic Palette of Colors

I love working with Liquitex Super Heavy Body acrylics, in part because they shrink far less than other brands, making it easier to create impasto brushwork that retains stroke crispness. Experiment to see what works for you.

Super Heavy Body acrylics: *Cadmium Red Medium Hue, Cadmium Yellow Light Hue, Titanium White, Transparent Burnt Sienna, Transparent Raw Umber, Ultramarine Blue (Green Shade) and Yellow Oxide*

Heavy Body acrylics: *Cadmium Orange, Cadmium Yellow Medium Hue, Dioxazine Purple, Payne's Gray, Phthalocyanine Blue (Green Shade), Quinacridone Crimson, Ultramarine Blue (Red Shade) and Unbleached Titanium*

Value Shift

Another peculiarity of acrylics is that they are a lighter value in their wet state than after they dry. This value shift occurs because the polymer emulsion used as a binder in acrylic paints is a milky color when wet, but it becomes clear when dry.

That milky color lightens the value of the paint, but the true darker value of the pigment is revealed when the binder turns clear. This can present a challenge when attempting to match a color that is already dry. The degree of wet-to-dry value shift varies from one brand of acrylic to another.

To further complicate matters, the more medium you add (which amounts to mixing in more of the milky-colored emulsion), the lighter you make the wet paint.

Unfortunately there's no magic trick to dealing with this maddening transformation other than to train yourself to anticipate it and mix your colors a tad lighter than you want them to be when dry.

Wet Acrylic
This is Liquitex Heavy Body acrylic fresh out of the tube before it has had a chance to dry.

Dry Acrylic
Notice how much the paint shrinks after drying.

To end up with thick paint strokes, avoid adding water or fluid glazing gels (they only magnify the shrinkage), and apply the paint at least 50 percent deeper than you want it to appear when dry. Practice on a scrap of canvas to determine how much more paint to use. Modeling paste can help, too.

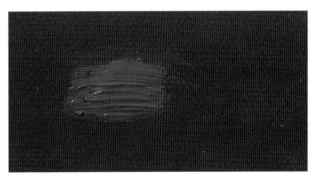

▲ Value Shift
The base layer is dried acrylic. I've added a stroke of wet acrylic of the same color to show the value shift between wet and dry acrylic paint.

◄ Additives
I use only a handful of the huge selection of acrylic mediums and textures available: Ceramic Stucco Texture Gel, Glazing Medium, Gloss Super Heavy Gel, Light Modeling Paste, Modeling Paste and Slow-Dri® Blending Gel.

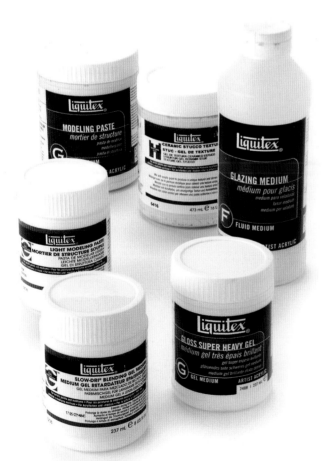

Acrylic Wet-Into-Wet

Because of the fast drying speed of acrylics, much of your work must be done wet-on-dry. In spite of this, it is possible to work wet-into-wet some of the time if you develop the appropriate strategies. The following list outlines methods for facilitating wet-into-wet painting with acrylics:

- Lightly mist the canvas before applying the paint.
- Mist wet paint frequently to keep it moist.
- Use thicker paint, which takes longer to dry.
- Plan your approach ahead of time.
- Mix all the basic colors before starting to paint.
- Paint one limited section at a time.
- Paint like your hair is on fire.
- Add acrylic retarder. (I rarely add retarder because it increases the shrinkage of acrylics while only slightly increasing the drying time.)

Misting acrylics, on the canvas as well as on the palette, is the most effective way to keep the paint fluid longer without increasing shrinkage. Use the finest mister you can find; steer clear of the plant mister variety that produces large droplets, which will practically wash the paint off your canvas. Beauty supply stores usually carry fine misters, or you can use an empty body spray or hairspray bottle to create the atomized mist that works best.

advantages and disadvantages of working with acrylics

Here are some positive qualities I've discovered about acrylics:

- Short drying time makes it possible to paint many layers in a single work session.

- You can paint as many layers as you want without being bound by fat-over-lean requirements (see page 12).

- The paint film is tougher and more flexible than that of oils, making it less prone to deterioration.

- Acrylics don't yellow with age.

- There are limitless glazing possibilities with all the gels available.

- It's easy to create textural effects with a large variety of mediums.

- Brushes are easier to clean.

- No toxic solvents are required (although some people are allergic to acrylic fumes).

These qualities can make working with acrylics difficult:

- Quick drying time makes painting wet-into-wet quite challenging.

- Acrylics dry by evaporation; when the water is gone, the mass of the paint body shrinks.

- Acrylics dry darker than they appear when wet.

◄ *Fine Mister (Correct)*
Get your hands on a fine mister that makes very small droplets. I buy mine at a beauty supply store.

▼ *Plant Mister (Wrong)*
The droplets created by a typical plant mister are too large.

Correct Misting Distance
Spray from far enough away so that the mist drifts onto the wet paint rather than shooting at high velocity. Hold the mister about a foot away from the painting surface.

16

palettes

traditional wood palette is a poor choice for acrylics or water-soluble oils—unless it's been thoroughly sealed with several coats of polyurethane varnish—because the wood grain absorbs water, swells and softens, and can even begin to release wood fibers into the paint. There are several good alternatives available. You'll need to find one that suits you.

All the palette styles shown below are equally suitable for acrylics, traditional oils and water-soluble oils, with the exception of the Sta-Wet palette, which is for acrylics only.

clean palette knife quickly

Wipe your palette knife blade immediately after every use. Acrylics dry almost instantly on palette knives because, unlike brushes, the blades retain no water.

Porcelain Butcher Tray ▲
I use this type of palette in my studio. The slick, hard porcelain surface allows for easy removal of dried paint and resists scratching.

Disposable Palette Pad ▲
The plastic-coated sheets are water resistant. The pad is inexpensive, and you simply dispose of the sheet when you're done or when dried paint buildup interferes with your work. Unfortunately the thin plastic surface wears through easily, exposing the paper below.

Plastic Palette ▲
If you prefer a hand-held palette, this style provides a lightweight and inexpensive alternative. And it's easy to clean. However, overly exuberant use of a palette knife can scratch and gouge the plastic surface.

Sta-Wet Palette ▲
Masterson sells a palette specifically for acrylics that is excellent. A thin sponge topped by a special water-permeable paper allows the acrylic paint to absorb water without the paint soaking through to the sponge. The paint stays moist while you paint.

The one downside to this product is that over a couple hours the paint continues to absorb water and starts to puddle. I use this palette for plein air painting with acrylics.

Styrofoam Picnic Plates ▼
Styrofoam plates are cheap, disposable and lightweight. The slick plastic surface is ideal for mixing acrylics. There are a variety of shapes with separate reservoirs as well as the standard open shape.

Palette Knife ▲
There are many exotic palette knife shapes designed for knife painting techniques. But I stick with a standard trowel with a 3" (8cm) blade. It mixes medium-to-large piles of paint yet is versatile enough to use for a fair amount of knife work.

paint consistency

\mathcal{E}ven though a great deal of the brushwork used in loose painting styles is very thick and unthinned by medium, there are still uses for paint of greater fluidity. Sometimes it's helpful to add a little medium to make paint flow more readily onto the canvas. Or a situation may call for an energetic, loose wash.

The consistency continuum (below) is an effective device to explain the viscosity of paint that I'll refer to when we begin the exercises.

To make it easier to understand the range of paint viscosities I describe, I've chosen a number of kitchen products with which nearly everyone will be familiar. When I refer to any particular consistency, let's say #5, you'll be able to refer back to its food equivalent (ketchup) and know exactly what I mean.

The continuum starts at peanut butter and margarine, which are very close in consistency to tube oil paint, and progresses all the way to cooking oil, which stands in for paint thinned to the max.

There are a number of mediums you can use to thin oils. To avoid toxic fumes, I limit myself to thinning the paint with either water (only for the initial washes) or water-soluble linseed oil. Acrylics, however, open up an entire world of mediums. You can mix those mediums into the acrylics with or without adding water to achieve any of the consistencies below.

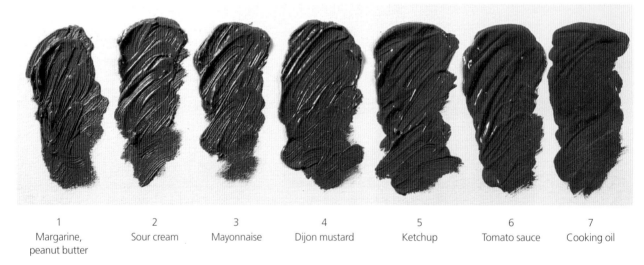

1	2	3	4	5	6	7
Margarine, peanut butter	Sour cream	Mayonnaise	Dijon mustard	Ketchup	Tomato sauce	Cooking oil

Consistency Continuum
Beginning with unthinned pigment at the left, the paint piles contain increasing proportions of medium as they move to the right. Their kitchen equivalents are listed beneath each consistency.

transparent or opaque

Paint becomes more transparent with the increasing addition of medium. If you want the paint to remain opaque, limit the amount of medium you add.

painting surfaces

depending on the look you want your work to have, along with the surface tooth you prefer to paint on, there is a range of surface choices available. In addition to buying acrylic or oil preprimed canvas and linen, you can purchase raw canvas, linen or different types of hardboard like masonite and create all sorts of surface textures by applying gesso with a brush, roller or palette knife.

Surfaces to Avoid

Before I discuss the main surface textures to use, I want to mention two types to avoid when working with oils.

Extremely smooth, slick surfaces, especially if they've been sealed with retouch varnish, are difficult to paint on because there is no tooth to keep the paint from skidding around; the paint just won't stay put as you work with it.

Overly absorbent surfaces suck too much of the oil from the paint, causing it to become unnaturally stiff and difficult to work with. In addition, if too much of the oil is absorbed by the painting surface, the paint film won't bond properly and will be more likely to crack and peel.

toxic heavy metals

Some pigments in both oils and acrylics contain the poisonous heavy metals cadmium, cobalt and, on rare occasions, lead. Exercise care when using paints containing these elements. Keep them off your hands, don't put brush handles in your mouth, and don't eat while painting. Paint readily transfers from your hands to anything you touch, including food.

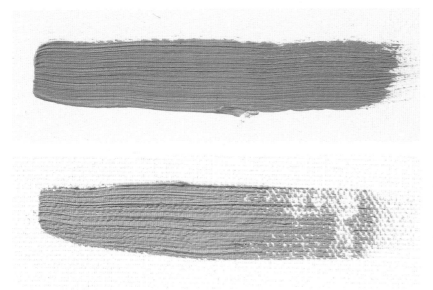

Smooth-Textured Surface
Fine-weave canvas or smoothly gessoed canvas, though easier to do refined brushwork on, can be used for thick impasto work if you don't want the weave of the canvas to influence the brushwork.

Medium-Textured Surface
A medium weave provides a pleasing tooth to paint over without its texture becoming a dominant element in the painting.

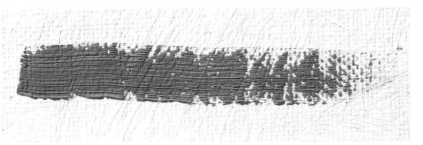

Coarse-Textured Surface
Coarse-weave canvas or linen can be made even rougher by priming them with a thick gesso or oil ground applied with a house-painting brush or palette knife. The painting surface itself interacts with the pigment, providing an added element of texture and randomness.

brushes

brushes are extensions of your hand and mind. Good ones can be a joy, while poorly crafted or poorly cared for brushes can make painting difficult. Because the focus of this book is on thick, expressive brushwork, most of the time we'll be using stiff bristle brushes, which are more effective at loading and manipulating thick globs of paint.

Bristle Brushes

In addition to effectively controlling thick paint, bristle brushes produce rougher-looking strokes, which can contribute to the expressive quality of brushwork. They also hold up better to the beating of continually stroking across coarse painting surfaces. If you think of canvas as a kind of sandpaper, you won't be far from the truth.

There are two types of bristles: synthetic hair and natural hog hair. I recommend using synthetics with both water-soluble oils and acrylics. The difficulty with natural bristles is that they absorb water when you rinse them or use them for washes. Water transforms them into limp mops that are difficult to control. Synthetic bristles are non-absorbent, so they maintain their shape and spring even when exposed to water. My favorite synthetic bristle brushes are the Bristlon series made by Silver Brush. They hold a fine edge, handle beautifully, and provide excellent control. Experiment to see what works for you.

keep brushes moist

Keep brushes moist while working with acrylics so paint doesn't dry on them. During a painting session, I place the tips of brushes I'm not using at the moment under a damp sponge.

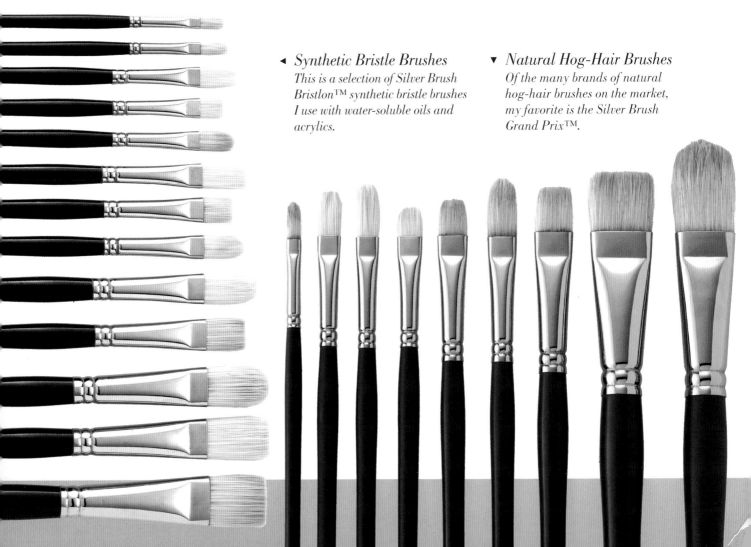

◄ *Synthetic Bristle Brushes*
This is a selection of Silver Brush Bristlon™ synthetic bristle brushes I use with water-soluble oils and acrylics.

▼ *Natural Hog-Hair Brushes*
Of the many brands of natural hog-hair brushes on the market, my favorite is the Silver Brush Grand Prix™.

Soft-Hair Brushes

The thinner, more flexible fibers of soft-hair brushes, whether natural or synthetic, make them ideal for detail work. Also, they don't generate the deep grooves and rough texture that bristles do, making them perfect for blending paint.

On the other hand, most soft-hair brushes lack the strength to manipulate large, heavy masses of paint, which makes them less suitable for bold brushwork. Their delicate fibers are also more susceptible to damage from painting on rough surfaces.

Most acrylics come from the tube less viscous than oils, so you don't necessarily need stiff bristle brushes to manipulate the paint. Unless you want the coarser texture that bristles create, soft-hair brushes have enough strength to work with many acrylics. But because I wanted heavy, rough brushwork and I like to paint with the thickest acrylics available, I used synthetic bristles for most of the work on the acrylic paintings in this book.

▶ avoid placing brushes tip-down in water

Don't keep your brushes tip-down in a jar—especially in water. The constant pressure on the fibers weakens them and, if left tip-down long enough, can give them a permanent curve.

Water will absorb into the wood handles, causing the wood to swell, minutely stretching the metal ferrule. When the wood dries, it shrinks down a little smaller than its original circumference. When this is repeated many times, the ferrule becomes loose to the point where it can actually fly off while you're painting.

▼ *Anatomy of a Brush*

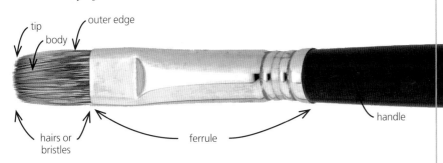

tip
outer edge
body
hairs or bristles
ferrule
handle

▼ *Soft-Hair Brushes*
This is a selection of soft-hair brushes I sometimes use when painting loosely.

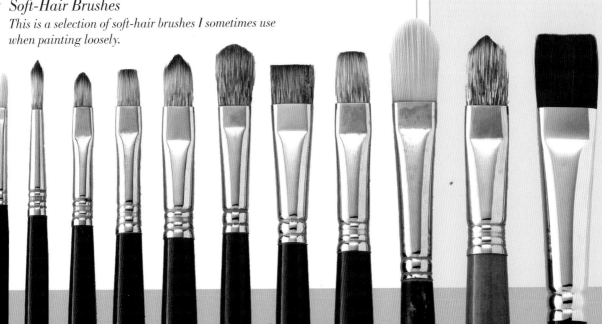

Brush Shapes ▶

The shape, length and thickness of the stroke you want will help determine the type of brush you choose.

Filberts naturally make rounded strokes. Flats and brights easily create square-end strokes.

Brights possess shorter bristles, making them stiffer and stronger than flats and filberts, so they are able to manipulate the thickest, heaviest applications of paint.

Filbert

Flat

Bright

go large

Using the largest brush possible that still allows you to exercise adequate control promotes thick and bold brushwork. Working with smaller brushes than necessary will tempt you to unconsciously create more refined and delicate strokes.

▼ Scrub Brushes

Old, worn-out bristle brights are perfect for blocking in or scrubbing in the initial wash. It spares your good brushes from rough work so they'll maintain good tips for more careful painting.

These two scrub brushes began their lives as no. 8 and no. 10 brights. Their worn condition testifies to the abrasive power of canvas.

▼ House Brush

An ordinary house brush is a handy tool for washing in or blocking in large areas. Just make sure it has enough control to suit your purposes and style.

This is the 1½" (38mm) house brush I use.

▲ Long-Handled Brushes

Painting with long-handled brushes allows you to stand back further from your work, making it easier to take in the entire picture and see how it's developing as a whole. This is especially helpful when painting on location because changing conditions and daylight typically limit working time; the better you see what you're doing, the quicker you can paint.

1

It's empowering to discover you can gain control of your brushwork by mastering simple techniques rather than being at the mercy of a hit-or-miss process that eludes your understanding. In this chapter you'll learn the mechanics of shaping brushes, loading paint and applying strokes that will enable you to create loose, expressive brushwork. For starters, realize that most of the work for each stroke is accomplished before the final expressive flourish of touching brush to canvas. In other words, to make the paint do your bidding it's essential to put it exactly where you want it on your brush with the right amount for the stroke you envision.

brushwork basics

CHAPTER 2

The five basic techniques described here are by no means the only possible approaches, but they provide a solid foundation for bold brushwork and can be adapted to create a variety of strokes. Let them serve as a springboard to experiment and discover other methods. You'll find more information about the fundamentals of brushwork in my previous book, *Brushwork Essentials*, which gives in-depth instruction about a wide range of brushwork techniques.

After studying this chapter, practice the techniques on scraps of canvas or board without using subject matter so you won't be distracted by drawing, color and values. You'll be surprised by how much you learn.

◄ **November's Roses**
Oil on linen on panel
16" × 12" (41cm × 30cm)

stroke preparation

astering dynamic brushwork requires learning to think through what you're doing with the brush and paint.

Your journey begins by envisioning the end result—the shape, size and thickness of the stroke you want. Once that is determined, you have to think backward to figure out where the paint needs to be on the brush to make that kind of stroke. Then you rewind another step and decide how to load the pigment so it ends up in the correct position on the brush.

Once you get the hang of it, the process will move smoothly and won't require much effort. What really generates sweat and frustration is blindly smooshing paint around with no idea of how to achieve the desired results.

Cleaning and Shaping

There's an important step to take even before loading the paint—cleaning and shaping the brush. This is simply a matter of regularly wiping your brush on a rag to eliminate the

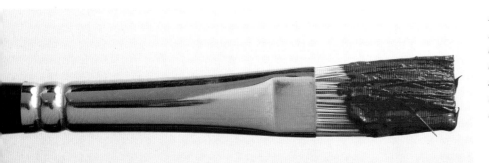

Before Cleaning
During the painting process, brushes become clogged with pigment. Paint buildup reduces a brush's flexibility, submerges the sharp tip and makes it much harder to control (unless it's large, smeary strokes you're after).

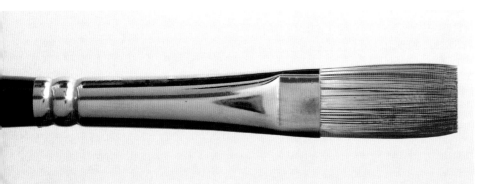

After Cleaning
With minimal effort, you can restore the brush's shape, point the tip, and remove most of the contaminating colors.

buildup of excess paint that can diminish brush control. It also lines up the bristles to a nice, controllable edge and removes contaminating colors.

Pull, Don't Push

When cleaning brushes between strokes, it's important that you pull—not push—the brush across or through your rag. Pushing will dramatically increase brush wear and splay the bristles. Pulling minimizes wear and lines up the bristles into a sharp edge.

There are a number of paint rag options, but I prefer cotton ones because they're absorbent and don't shred or generate lint.

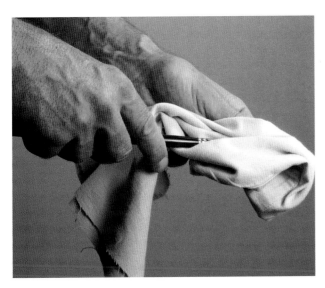

Rag in Hand
Pull the brush through a firmly held rag to wipe off the paint and shape the brush's body. If you're not using thick rags, it's a good idea to double them over; otherwise the pressure your fingers exert may force paint through the fabric and you'll end up with multicolor goo all over your hands. (And that goo has a way of traveling everywhere.)

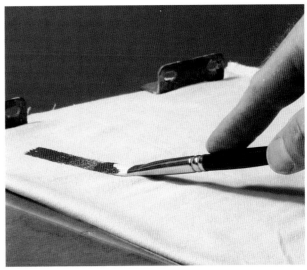

Rag on Flat Surface
If you work on a palette table, as I do in my studio, it helps to clip the rag to the surface so it stays put when you drag the brush across it. (I attached a couple of spring cabinet door hinges to secure the rag.) Firmly pull the brush over the rag to clean one side (exerting pressure on the bristles, not the ferrule), then turn the brush over and wipe the other side.

tip-pull loading and application

The tip-pull loading and application technique is the workhorse of the strokes in loose brushwork. It's versatile enough to allow you to paint refined strokes all the way through thick and rough applications of pigment, and you can achieve most of the bold stroke effects you want. The other techniques I've included employ more specialized strokes with limited uses.

Tip-pull loading involves pulling through or over the top of a paint pile to load pigment on the brush tip. It's quick and easy to reach to your palette, snag a wad of paint, and briskly lay it on the canvas.

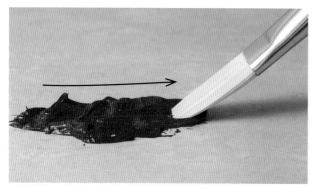

Tip-Pull Loading
Hold your brush at a medium to steep brush-to-palette angle and draw the tip of the brush through the top or edge of the paint pile. To control the amount of paint on the brush, simply go deeper or shallower into the pile. Before applying the paint, look to see how much you actually loaded to avoid surprises like laying down a chunk where you wanted a dash, or a dot where you intended an energetic sweep.

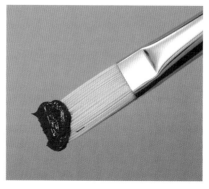

Tip-Pull Load Ready
The tip holds a nice load of paint and, because you know exactly where the paint is on the brush, it's possible to generate a wide variety of shapes and thicknesses without a lot of thought.

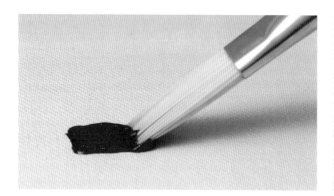

Tip-Pull Load Application
Turn the paint-side down. For thicker paint application, touch only the paint to the canvas. The more you press the brush, the more it flattens out the paint. For longer strokes, apply the paint with a shallow brush-to-canvas angle.

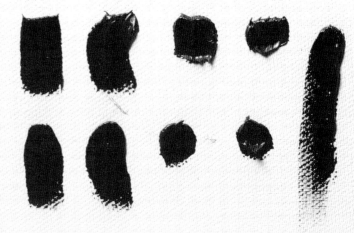

Tip-Pull-Loaded Sample Strokes
You can create anything from a short dash of a stroke to a long sweep of paint with the tip-pull loading method.

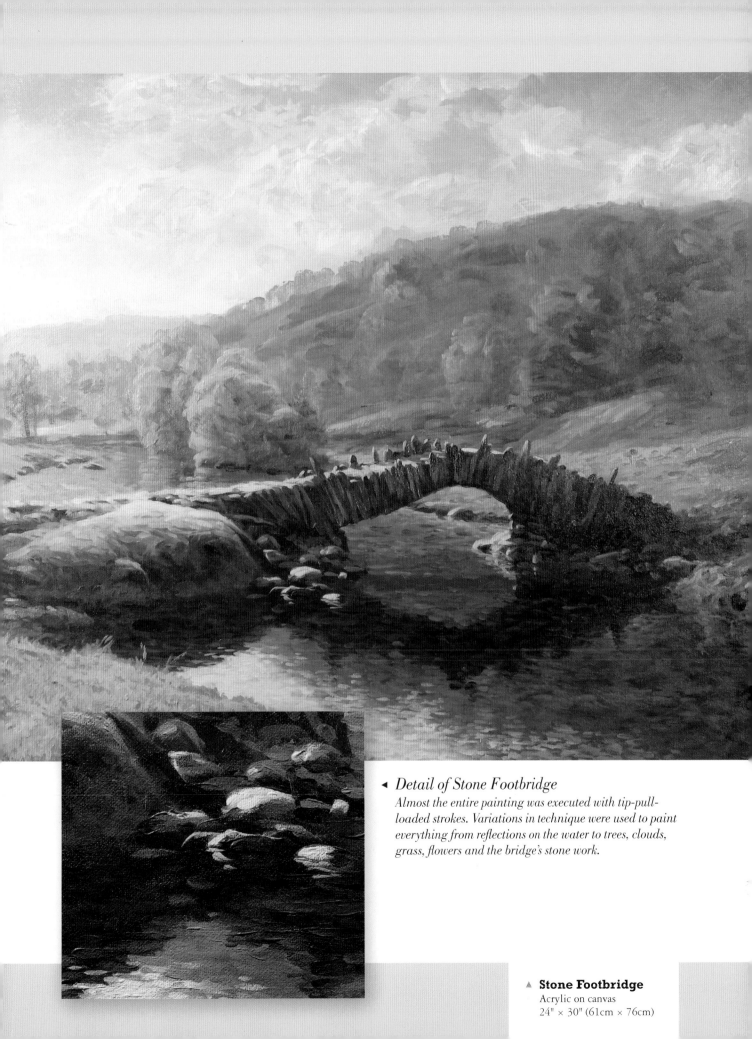

◄ *Detail of Stone Footbridge*
Almost the entire painting was executed with tip-pull-loaded strokes. Variations in technique were used to paint everything from reflections on the water to trees, clouds, grass, flowers and the bridge's stone work.

▲ **Stone Footbridge**
Acrylic on canvas
24" × 30" (61cm × 76cm)

chisel loading and application

To achieve precise strokes that can range from long, thin lines to strokes that start thin and widen as they go, use the chisel loading technique.

Since you want control when you employ this method, use brushes that are in good shape and can hold a sharp edge.

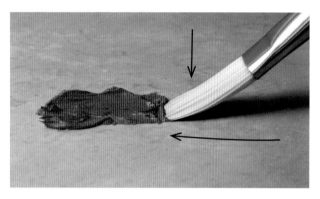

Chisel Loading

Push down and forward at about a 45-degree angle to compress the bristles into a chisel tip. This will allow you to pick up a narrow ridge of paint right on the edge. Lightly push forward into a shallow area of your paint pile. Pushing into a deep section of the paint will deposit a thick, difficult-to-control glob on your brush.

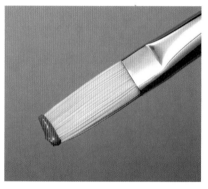

Chisel Load Ready

With a thin bead of paint right on the brush tip, you know exactly where it is and can exercise maximum control for precise and sharp-edged brushwork.

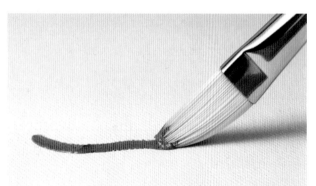

Chisel Load Application

For thin lines, hold the brush at a medium-to-steep angle to the canvas. Apply light pressure as you draw the brush along. To widen a stroke, turn the brush width-wise and apply more pressure.

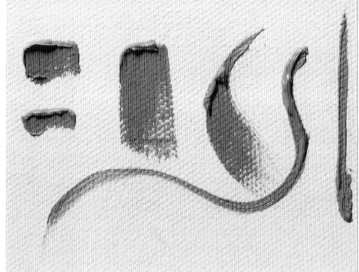

Chisel-Loaded Sample Strokes

Flats and brights can be used to make a variety of controlled strokes. Though the paint isn't thick, this technique can be used to create expressive brushwork like staccato rectangular jabs, lyrical wavy lines, and flowing calligraphic-like accents.

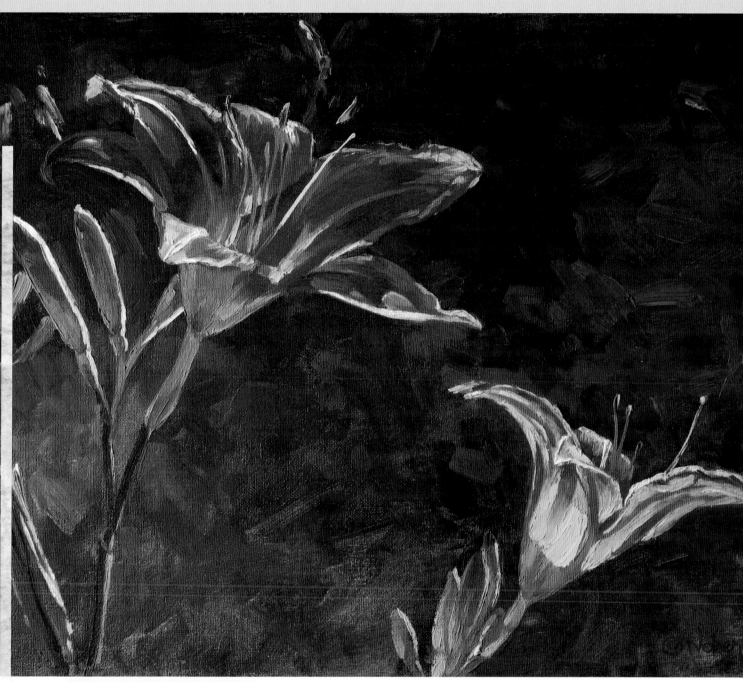

◄ *Detail of Two Orange Lilies*

All the thin lines—mostly highlights—in the flowers were painted with chisel-loaded strokes. Even though most of the picture is painted loosely, the fine lines give it a much crisper and real appearance.

▲ **Two Orange Lilies**
Oil on canvas on panel
12" × 16" (30cm × 41cm)

body loading and application

If you want very thick paint application or long, fluid strokes, the body-load stroke is ideal because it enables you to slap on great globby swaths of rollicking pigment. It's called the body load because you pick up paint on almost the entire length of the brush body. A shallow brush angle is required much of the time for both loading and application. Holding the brush like a conductor's baton rather than a pencil makes it easier to work at the low angle.

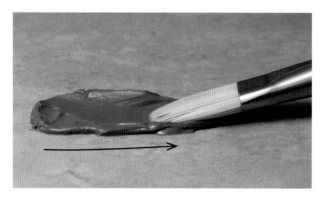

Body Loading
Holding the brush at a shallow brush-to-palette angle, draw the brush through the top of the paint pile. Use light pressure as you pull.

Body Load Ready
The key is to load paint all along the brush body. Avoid loading paint on the ferrule where it tends to develop a mind of its own and lands in places you don't intend. Once again, even though you're working with a whole lot of paint, because you know exactly where it's located on the brush you can control how you lay it on the painting.

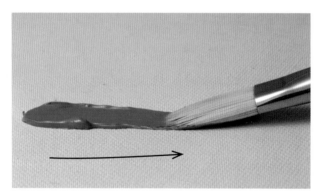

Body Load Application
For a thick impasto stroke, apply the paint at a very shallow brush-to-canvas angle using light pressure. In spite of the impression of forceful painting this technique gives, it actually requires a delicate touch. When you press down on the brush, the bristles dig into the paint, flattening the paint body or pushing it to the sides and making more of a channel shape with steep, sharp sides rather than a full-bodied mass. For especially long strokes, begin with your brush at about a 45-degree brush-to-canvas angle and gradually lower it as you pull.

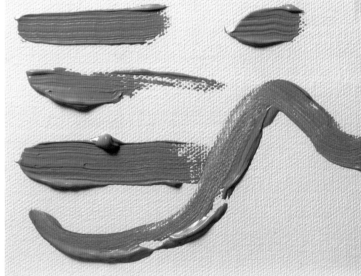

Body-Loaded Sample Strokes
Bold, thick impasto strokes and long, fluid paint applications are the hallmark of this technique.

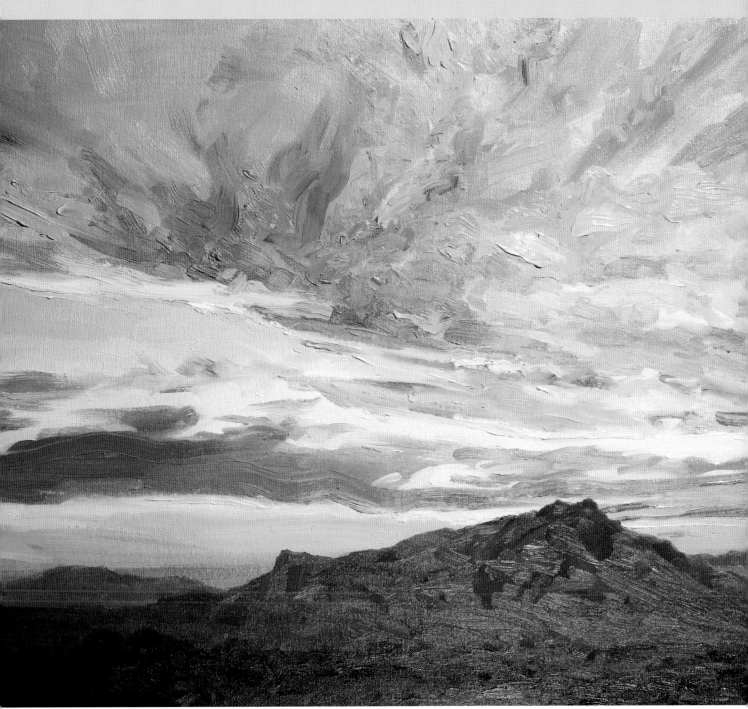

◄ Detail of Fiery Sky

Most of the long horizontal areas of sunlight on the clouds were painted with body-loaded strokes of #1- and #2-consistency paint. I also used body-loaded strokes in a few smaller areas of the intense orange where I wanted really thick chunks of pigment. For those, I laid the paint straight down on the canvas without pulling it along.

▲ Fiery Sky
Oil on canvas on panel
16" × 20" (41cm × 51cm)

body fill-up and application

Unlike all the previous strokes where the pigment is on the bristles in various locations and amounts, the body fill-up technique soaks paint into the entire brush body. It's great for painting long, washy strokes to create an effect of energetic spontaneity and a dynamic "painting in progress" impression. It's also useful for soaking up large amounts of thin pigment to wash in large areas.

The paint needs to be thinned to a #6 or #7 consistency. Place the body of the brush in the paint and allow it to soak up as much paint as your application requires. Because the paint is so fluid, you may need to exercise care in getting the brush to the canvas without dripping.

Body Fill-Up Technique ▶
Thin the paint to a #6 or #7 consistency so the brush body can soak it up. Gently work the body of the brush around in the paint until it absorbs as much pigment as you'll need.

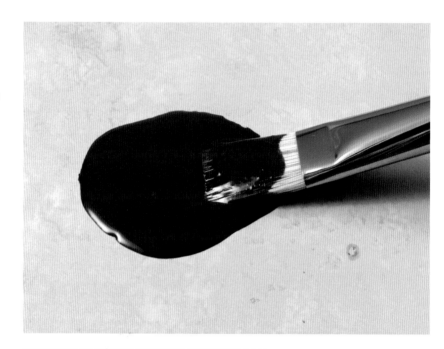

Body Fill-Up Stroke ▶
Paint a long, washy stroke with a no. 12 filbert. This loading and application technique can give an impression of dashing spontaneity.

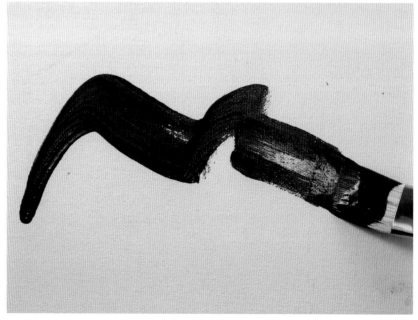

energetic but deliberate

Just because a stroke looks energetic doesn't mean it was quickly applied. It's the shape, texture and flow of the stroke that makes it appear energetic. And a dynamic-looking stroke might have been slowly and deliberately brushed on.

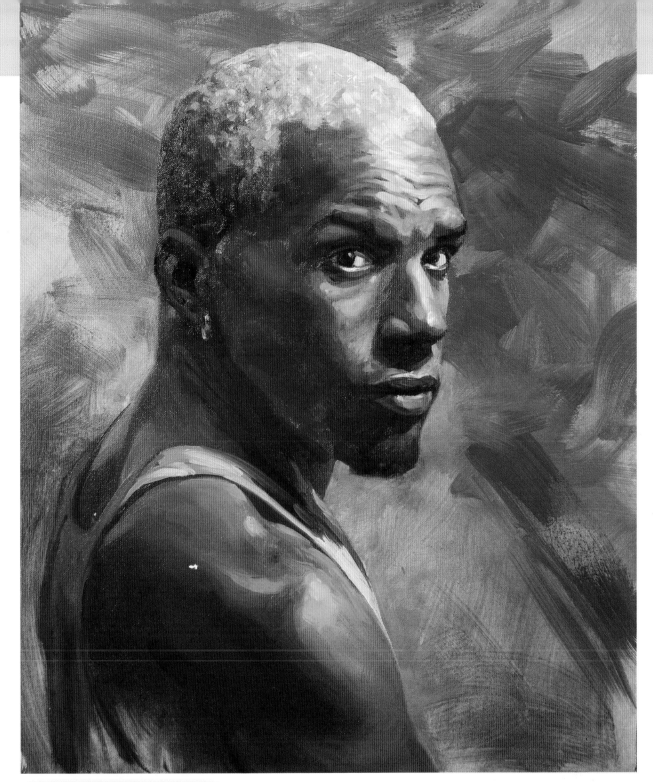

◄ *Detail of Man with the Golden Hair*
The background of this painting contributes a sense of motion. Though it looks spontaneous, I put more work into it than is apparent: I was unsure about the colors I wanted to use, so I tried five different combinations on canvas scraps—practicing the large, fluid strokes.

Before executing the background, I labored at the drawing to make sure the head was correct so I wouldn't need to adjust the background after laying it in. Only then did I proceed with the background washes, soaking up #7-consistency paint into a no. 16 bright and painting the flowing green areas with a few quick strokes.

▲ **Man with the Golden Hair**
Oil on canvas on panel
20" × 16" (51cm × 41cm)

Sometimes you might want to create irregular, straggly beads of paint, and the splay stroke is designed to do just that.

This technique works best with filberts, flats and rounds; the bristles of brights are too short to splay out enough to achieve the desired effect. Use brushes that are already worn so you don't abuse your good brushes. Old bristles (especially synthetics) will already be weak and tending to splay anyway.

Those of you who have read *Brushwork Essentials* know how finicky I am about brush care and will understand it's difficult for me to present this material, but we must make sacrifices for our art.

Holding the brush at a steep angle, mash it straight down into the palette so that the bristles spike outward. Then, hold the brush at a shallow angle and push the bristles over the top of the paint pile or straight into it. Push the brush across the canvas at a shallow angle to apply the paint.

You can also push down and sort of scrape the brush sideways on the painting surface. Either way, the bristles will be forced to splay out awkwardly to distribute the paint in haphazard directions, making streaky smears any slug would be proud of.

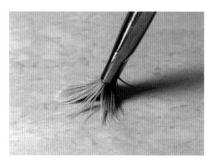

Splay Stroke Un-Shaping
Because you're aiming for an irregular, sloppy kind of effect with this technique, you essentially un-shape the brush. Jam the bristles straight down into the palette so they spread out.

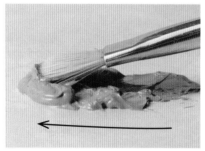

Splay Stroke Loading
To load paint onto your brush, push the splayed-out bristles over the top of the paint pile or run your brush straight into it.

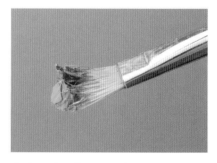

Splay Stroke Ready
Contrary to the previous techniques, the bristles should be poking out haphazardly. As ragged as it looks, you're ready to go.

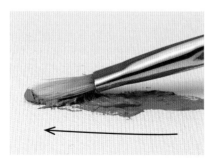

Splay Stroke Application ▲
Hold your brush at a shallow angle and push down and forward to leave a straggly trail of pigment.

Splay Stroke Examples ▶
The strokes are quite peculiar looking, but that's the idea.

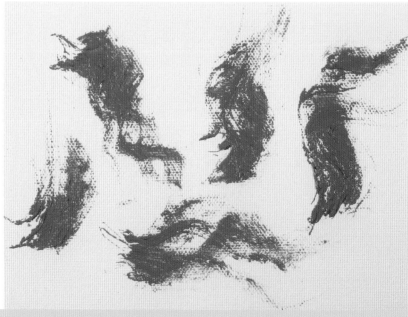

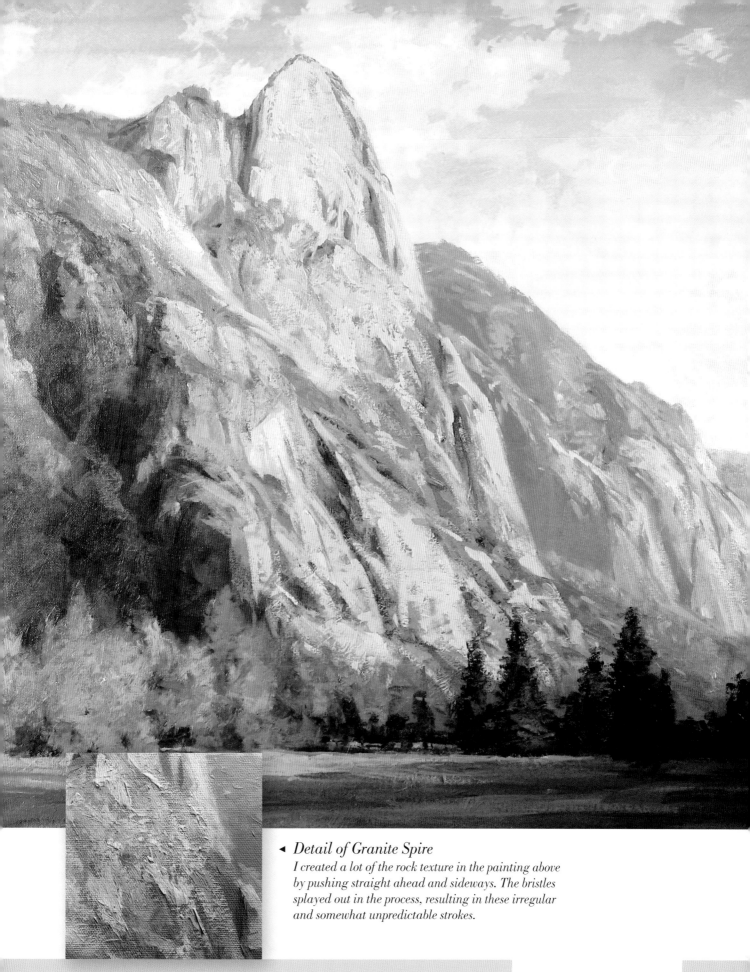

◄ *Detail of Granite Spire*
I created a lot of the rock texture in the painting above by pushing straight ahead and sideways. The bristles splayed out in the process, resulting in these irregular and somewhat unpredictable strokes.

▲ **Granite Spire**
Acrylic on canvas on panel
24" × 24" (61cm × 61cm)

I find painting in a loose, bold style more difficult to master than working in a smooth, realistic technique. I know that I can blend my way out of almost any problem when painting in a detailed, realistic style. But with bold brushwork the whole idea is for the paint strokes themselves to carry a large portion of the interest of the painting, and as soon as you begin blending your thick strokes around, you've defeated your purpose. The challenge is to mix the right color with the right value, place it in the right location with the right shape and then leave it alone!

Though I've designed this book to help you learn to paint loosely, the principles also apply to realistic techniques. Regardless of the delicacy of your pictures, at some point you must make a finite stroke of paint. *Bold Strokes* trains you to focus on each stroke in a way that contributes to the entire effect of the painting regardless of the style you're working in.

the bold challenge
CHAPTER 3

Approach the exercises as a fun learning experience. Most of us, whenever we pick up a brush, feel compelled to make everything the best we possibly can. That quest for perfection will lead us to consciously or unconsciously avoid taking the risk of trying new things, but it's taking those calculated risks that results in learning. Adopt a lighthearted approach of "Let's see what happens when I try this," and let'er rip. The more fun you have with it, the quicker you'll learn.

◄ **Fountain Fish Riders**
Oil on canvas on panel
20" × 16" (51cm × 41cm)

bold brushwork effects

One of the chief purposes of bold brushwork is to add visual interest to paintings. All sorts of dramatic results can be achieved through manipulating thick paint. The next few pages show some commonly used effects.

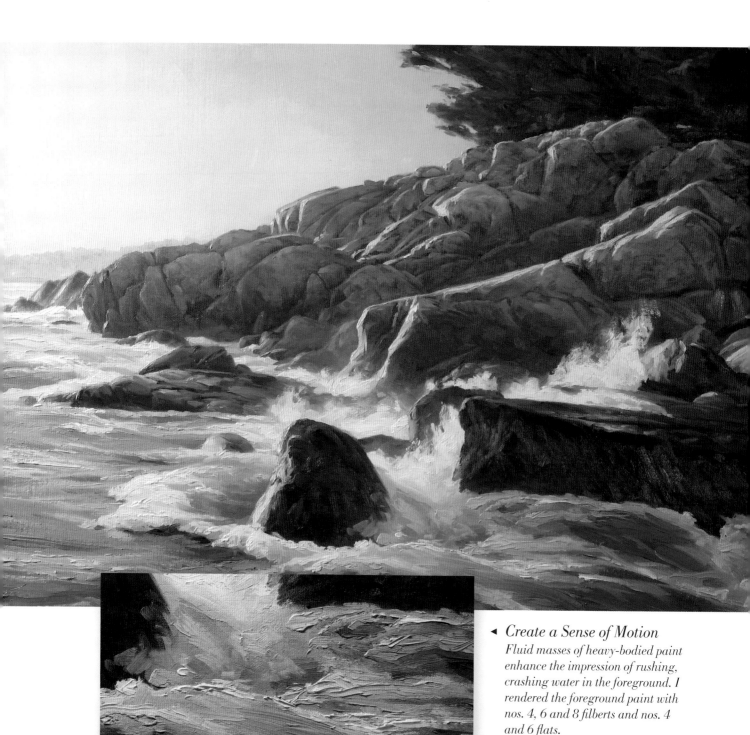

◄ *Create a Sense of Motion*
Fluid masses of heavy-bodied paint enhance the impression of rushing, crashing water in the foreground. I rendered the foreground paint with nos. 4, 6 and 8 filberts and nos. 4 and 6 flats.

▲ **Monterey Surf**
Oil on linen on panel
20" × 30" (51cm × 76cm)

▼ Red Rose on Lace Tablecloth
Oil on linen on panel
12" × 16" (30cm × 41cm)

▲ Catch Light for Dazzling Highlights

Thick ridges and chunks of paint used to render the highlighted areas of the tablecloth catch extra light and create brighter sparkling areas. I painted the highlights on the lace with a patchwork of thick rectangular strokes and long juicy swaths using a no. 6 flat while keeping the paint on the shadow areas relatively thin.

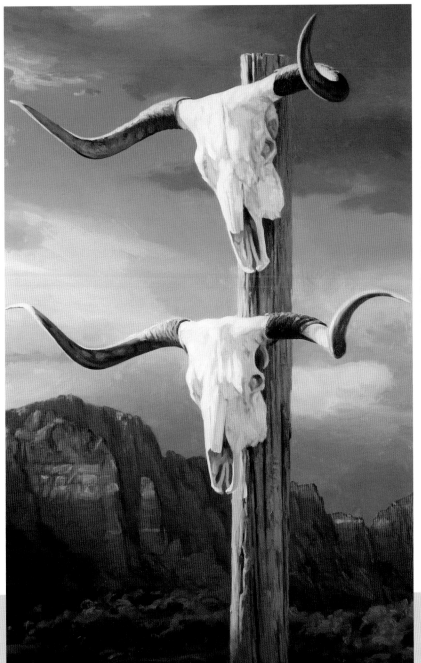

▲ Make Objects Appear Closer

I painted the sky and landscape with relatively thin paint. Then, to make the skulls and post stand out from the background, I applied much thicker paint with nos. 4, 6 and 8 filberts. As a bonus, the thick brushwork dramatized the strong, graceful curves of the horns and the weathered texture of the skulls.

◄ Skulls
Oil on canvas
36" × 24" (91cm × 61cm)

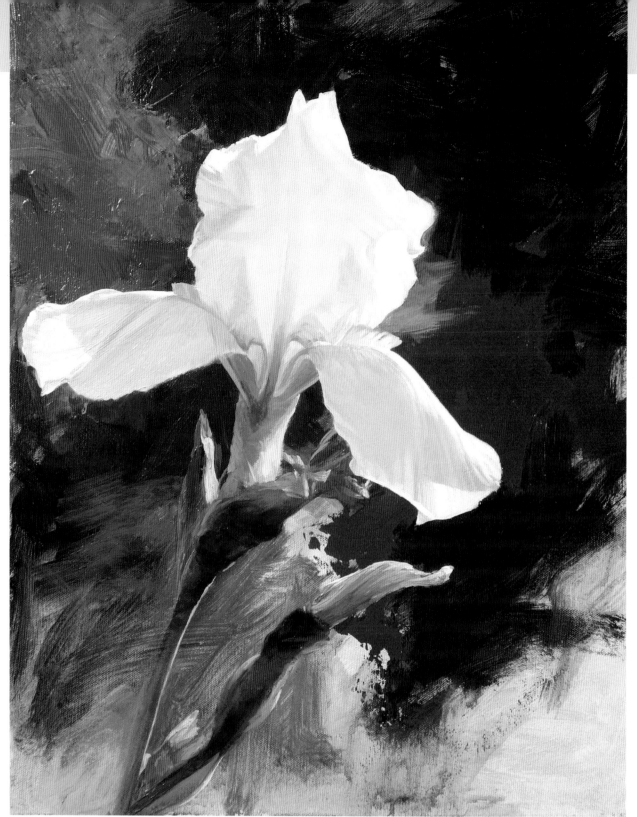

◀ *Create Emotional Impact With Thick Paint*
Though the flower is handled realistically, the thick,
gushing paint of the background heightens the
emotional effect of the picture. I used an old 1½"
(38mm) hog-hair house-painting brush to slather
on the brilliant red.

▲ **Iris, White and Red**
Acrylic on canvas on panel
20" × 16" (51cm × 41cm)

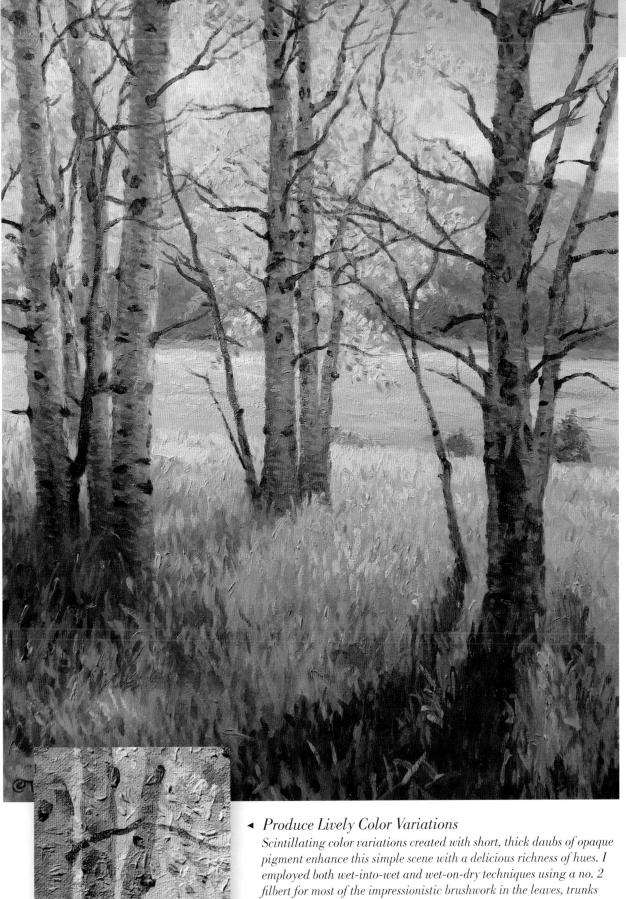

◄ *Produce Lively Color Variations*
Scintillating color variations created with short, thick daubs of opaque pigment enhance this simple scene with a delicious richness of hues. I employed both wet-into-wet and wet-on-dry techniques using a no. 2 filbert for most of the impressionistic brushwork in the leaves, trunks and grass.

▲ **Aspens**
Acrylic on canvas
24" × 18" (61cm × 46cm)

the power of practice

I thought about calling this section "unleash your creativity through discipline and practice," but concluded that that's not a very catchy concept. But catchy or not, practice is your most powerful tool for learning these techniques and freeing your mind for greater creativity.

As you begin the exercises in this book, nearly all of your concentration will be focused on the new techniques. But as you acquire some of the knowledge, that part will become second nature, which will free up a good portion of your mental—and creative—capacity.

The extra room in your head drive may not be noticeable at first, but as you continue to diligently practice, and approach mastery of the methods, you'll find yourself becoming aware of new creative options.

At that point the whole process will kick into gear. Learning will cease to be work and will blossom into an artistic adventure—all because you chose to hammer away at the basics until they became second nature.

The fundamental skills are laid out in a simple format. Practice them until they become habits.

An Early Passion for Art
Even when she was just a toddler, my daughter Zephra understood the devotion it takes to excel in art.

▲ **Practice, Practice, Practice**
Oil on canvas
16" × 20" (41cm × 51cm)

44

drawing and measuring

Sound drawing skills are crucial for working in a loose painting style because you must place strokes, colors and values correctly without fiddling with them. In addition, when working with much larger areas and strokes of paint, any initial drawing will be covered up at a very early stage in the painting.

Measuring is the best way to improve your drawing, and it's a simple skill. Make measuring a routine part of your painting practice. The process becomes a lot more fun once you've done the work to get the placement and drawing correct.

The most practical tool for measuring is your brush handle. Why use a brush handle? Aren't there more sophisticated instruments available? The brush handle, especially when working from life, is extraordinarily effective because it provides a simple yet uncompromis-

ing standard. And since it's already in your hand it saves you from digging around in your equipment to pull something else out.

The brush handle may be simple, but it doesn't mislead, flatter, lie or fudge. You can rely on it to provide an objective guide for comparing your painting to the subject.

There are three ways to use your brush handle to measure:

1. Compare proportions of different parts of the subject and painting.
2. Check angles of basic lines and shapes.
3. Check the relative vertical and horizontal alignment of compositional elements.

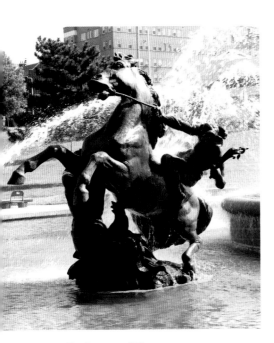

Reference Photo

the measuring habit

When in doubt, measure. When not in doubt, measure.

▲ Step 1: **Position**

Close one eye. Hold your arm straight with your elbow locked to insure that the brush handle will be the same distance from your eye for every item you measure. Otherwise you'll unwittingly change the distance of eye to brush as you move from one element of the subject to another, skewing your proportions in the process. Once your elbow is locked, line your brush handle up with whatever you're measuring.

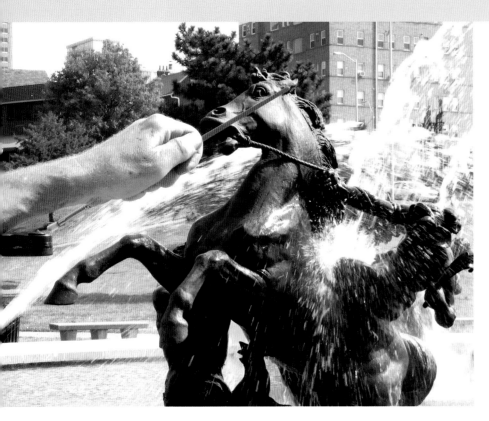

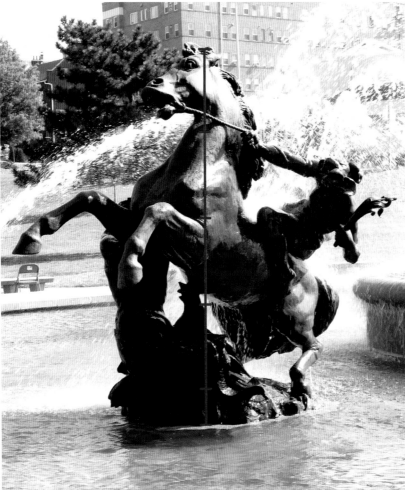

Step 2: Measure the Subject

Put the tip of the brush handle at one end of the shape you're measuring and use your thumb to mark the other end. In this example, I place the brush handle tip at the back of the horse's head and mark the end of the mouth with my thumb.

Step 3: Compare Lengths

In this example, I'm comparing the length of the horse's head to the height of the entire sculpture. To do that, I keep my thumb in the same spot and measure down the figure from the crown of the horse's head to the base and discover the number of times the head length goes into the height. In this case it's four and a half.

And that's just the beginning; I also compare the head length to the rider from his knee up to the top of his head, and to the length of the horse's forelegs and the width of the horse's body, and so on.

▲ Step 4: Measure the Painting

Once you've started the painting, employ the same method to measure the respective elements in it. But remember—it's a matter of the proportions, not the actual length. How many times does x (in this case the horse's head) go into any other part of the subject? It may sound a little like junior high math, but it's actually a lot easier.

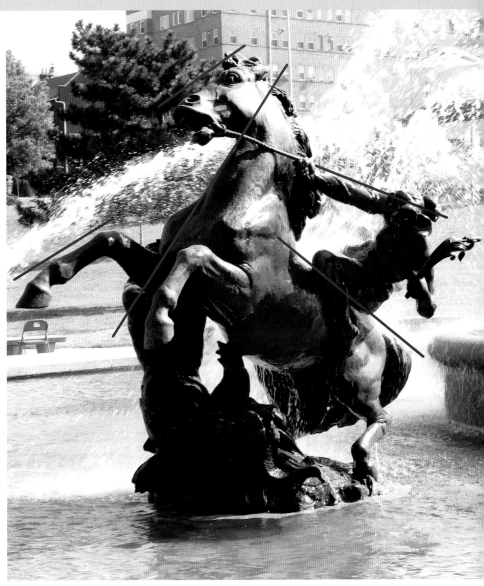

fix drawing errors early

As soon as you discover a drawing error, correct it! Don't blunder ahead with other parts of the painting, hoping that somehow the problems will work themselves out. The longer you put off rectifying drawing problems, the more work and frustration you create for yourself later on. It's such a pain to discover an area you thought was complete needs to be moved half an inch up or to the right.

▲ Step 5: Check Angles

Now you need to check the angles of the subject relative to the painting. First find a line in your subject you want to check. With only one eye open, hold your brush handle out steadily and line it up with the line you're measuring. Notice the angle of the handle. Then, without altering the angle of the brush, swing your arm over to your painting and hold the handle up to the corresponding line. Compare the brush's angle to the angle in the painting. It's amazing how much objectivity the simple yet uncompromising straight line of your brush handle can provide.

There are all sorts of angles in this sculpture. I've marked a few of the most crucial that I would check with my brush handle very early in the process: the angles of the horse's head, neck and forelegs; the slope of the horse's back; and the angle of the rider's right arm.

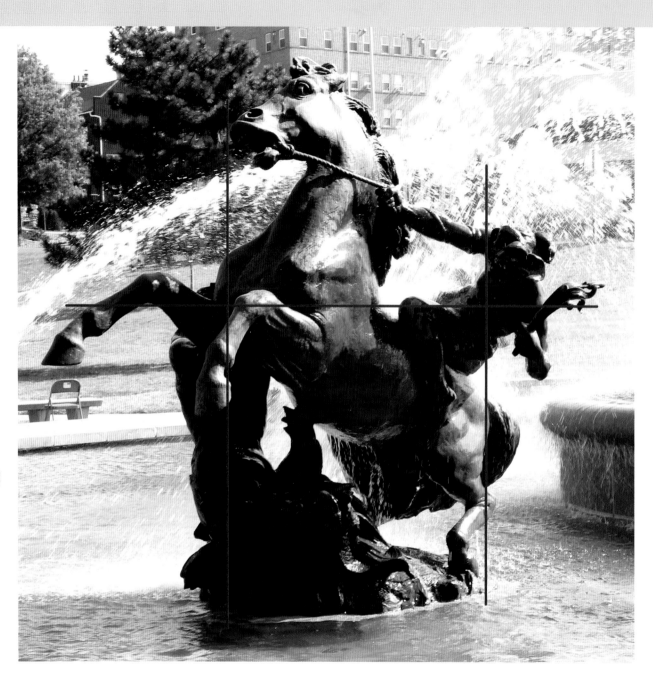

▲ Step 6: **Check Vertical and Horizontal Alignment**

Determining how various elements of the subject relate to one another vertically and horizontally is also very helpful in getting your drawing right. Using a horizontal line to compare the height of the rider's knee with the horse's knees, you'll discover that the horse's left knee is slightly higher than the rider's knee, and the horse's right knee is even higher.

Measure vertically from the horse's lip and note that the line passes a little to the right of its shoulder and just clips the left hoof. Do the same thing on the right side and you'll see that the rider's armpit is directly above the horse's buttock and just inside the bent hock.

landscapes vs. portraits and figures

When painting a landscape, getting the drawing correct is somewhat less crucial than it is for a portrait or figure. If a mountain is half an inch off, people usually won't notice; but for a face, even very small inaccuracies can be disastrous.

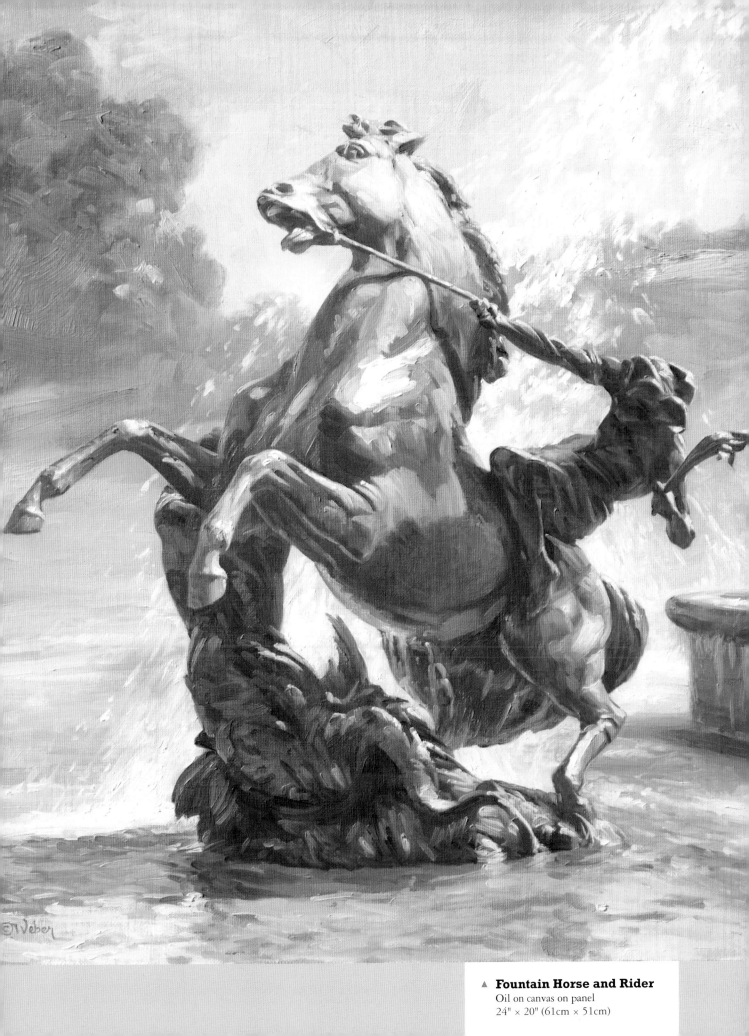

Fountain Horse and Rider
Oil on canvas on panel
24" × 20" (61cm × 51cm)

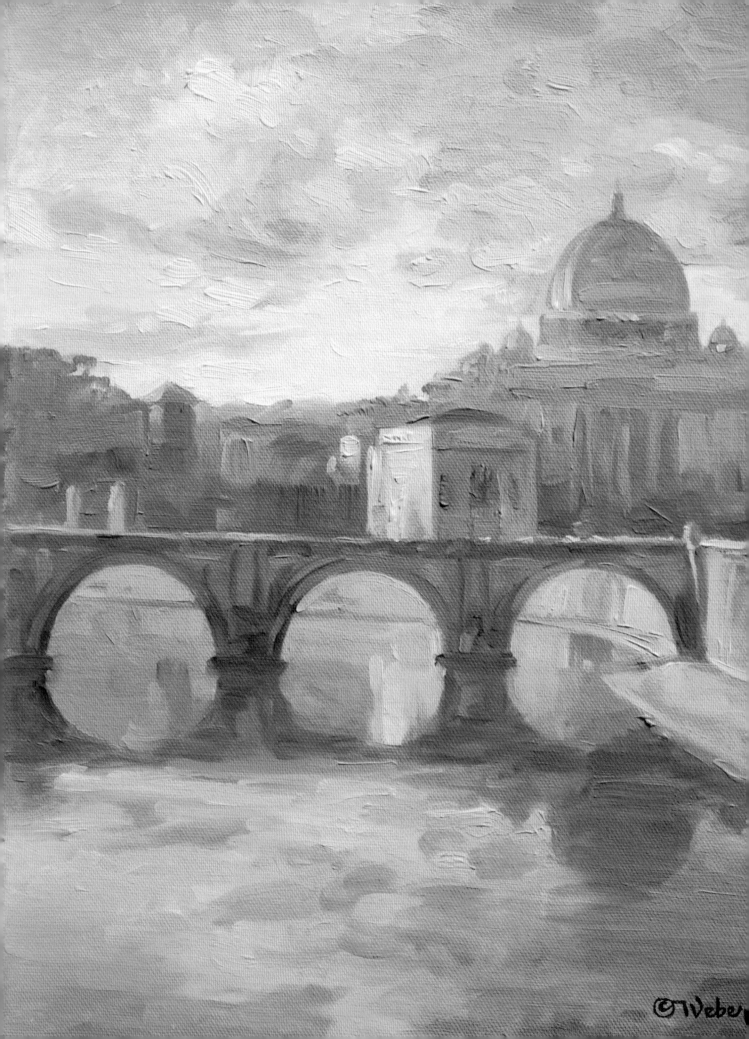

Standing before a magnificently painted seascape, you almost feel you are there—the tang of salt spray filling your nostrils; the wind, heavy with moisture, rushing over you. That is the power of suggestion, or, more accurately stated, the interpretive power of the human mind at work. We want to harness that mental capacity to enhance the viewer's experience of our paintings. And it doesn't hurt that it saves time and work to boot.

the power of
suggestion
CHAPTER 4

Our brains are chock full of visual experience, and very early in life we develop powerful habits of interpreting that information. By employing skillful techniques of painterly suggestion, we can unlock that treasure trove of experience and trick the viewer's mind into automatically supplying far more detail than we could ever paint. Instead of rendering each tiny detail, we can suggest aspects of the subject. It isn't necessary to paint every blade of grass to help the viewer experience the beauty of a field.

51

◄ **Evening, Rome**
Oil on canvas on panel
14" × 11" (36cm × 28cm)

suggesting texture

Loose brushwork can effectively suggest a variety of textures with only a few bold strokes. The paintings on the following six pages illustrate several textures and surfaces that can be achieved with a minimum of strokes and a maximum of satisfaction.

◄ Foliage
I loosely applied thick paint with nos. 4 and 6 filberts to suggest not only the trees in the middle ground, but the forest on the distant mountain. As I progressed to painting nearer grassy sections of the picture, I used increasingly thick paint to make it appear closer and at the same time imitate the texture of the ground cover.

▲ Meadow's Edge
Oil on canvas on panel
20" × 30" (51cm × 76cm)

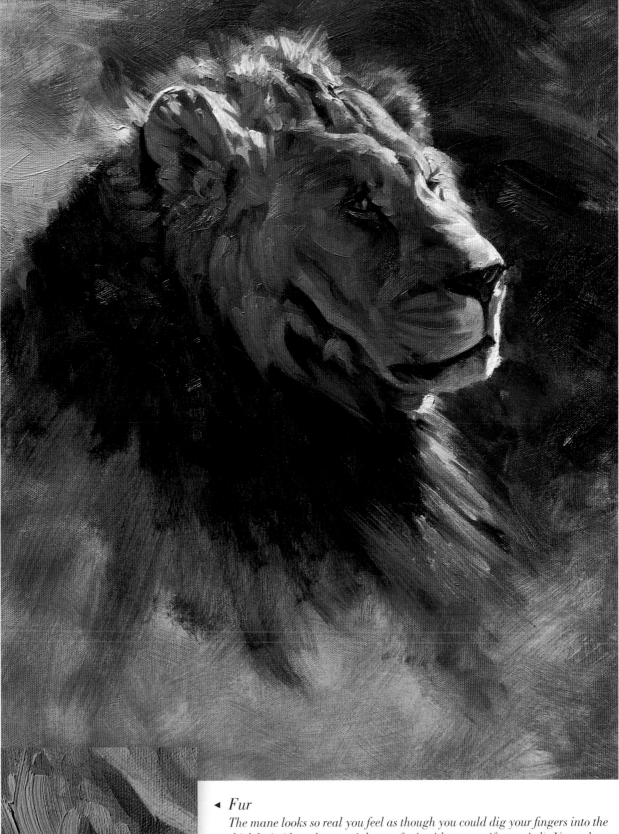

◄ *Fur*

The mane looks so real you feel as though you could dig your fingers into the thick hair (though you might pay for it with an arm if you tried). Upon closer inspection, you see vigorous-looking strokes of paint applied with nos. 4 and 6 filberts and a no. 6 bright to boldly convey the illusion of fur with minimal effort. The background was loosely brushed in with a 1½" (38mm) house brush, as were most of the tufts of fur along the crown of the head and ear that streak into the green background.

▲ **The Mane Attraction**
Oil on canvas
20" × 16" (51cm × 41cm)

Quiet Corner—Lake Powell
Oil on canvas on panel
24" × 20" (61cm × 51cm)

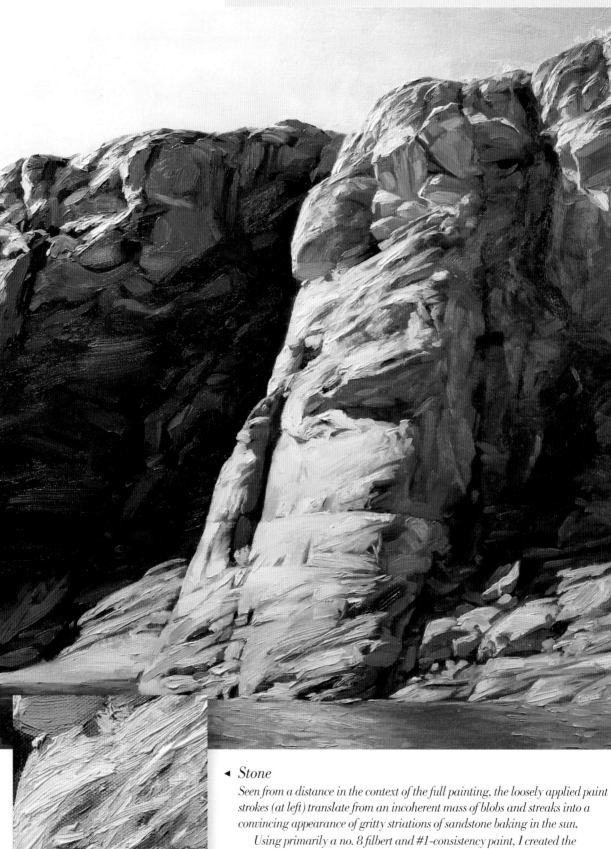

◄ *Stone*

Seen from a distance in the context of the full painting, the loosely applied paint strokes (at left) translate from an incoherent mass of blobs and streaks into a convincing appearance of gritty striations of sandstone baking in the sun.

Using primarily a no. 8 filbert and #1-consistency paint, I created the sandstone texture by stroking the thick pigment for the highlights in the same direction as the grain of the stone.

◄ *Clouds*

Thick strokes heighten the effect of evening sunlight illuminating the billowing edges of cloud masses, as well as adding drama and a sense of motion. After mixing modeling paste with unthinned Super Heavy Body acrylic to minimize shrinkage of the paint, I laid the pigment for the highlights on nice and thick with nos. 6 and 8 filberts.

▲ **Clouds on a High Hill**
Acrylic on canvas on panel
14" × 18" (36cm × 46cm)

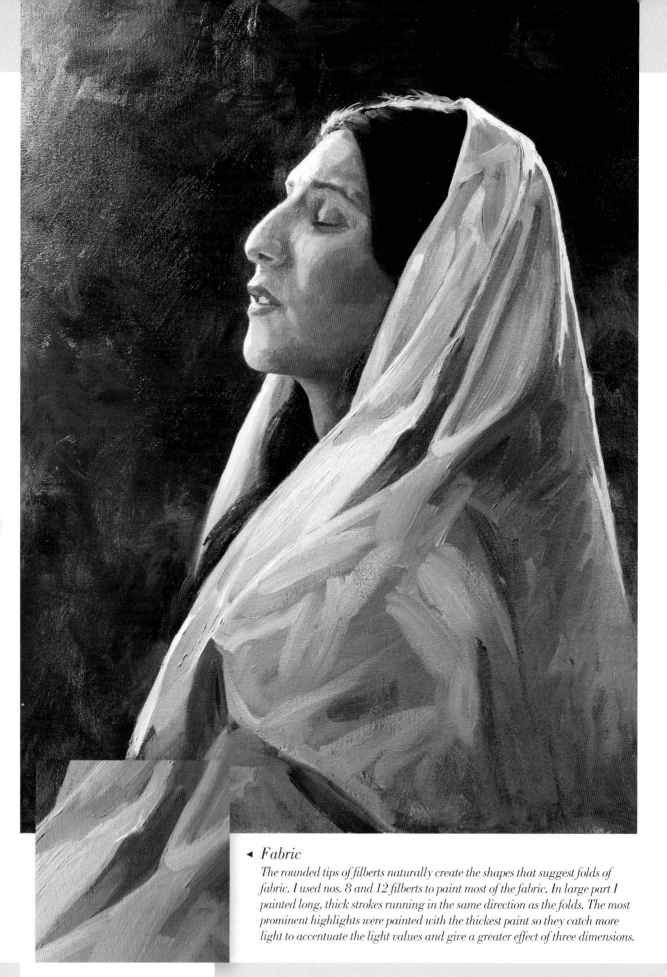

◀ *Fabric*
The rounded tips of filberts naturally create the shapes that suggest folds of fabric. I used nos. 8 and 12 filberts to paint most of the fabric. In large part I painted long, thick strokes running in the same direction as the folds. The most prominent highlights were painted with the thickest paint so they catch more light to accentuate the light values and give a greater effect of three dimensions.

▲ **The Moment**
Oil on canvas on panel
24" × 18" (61cm × 46cm)

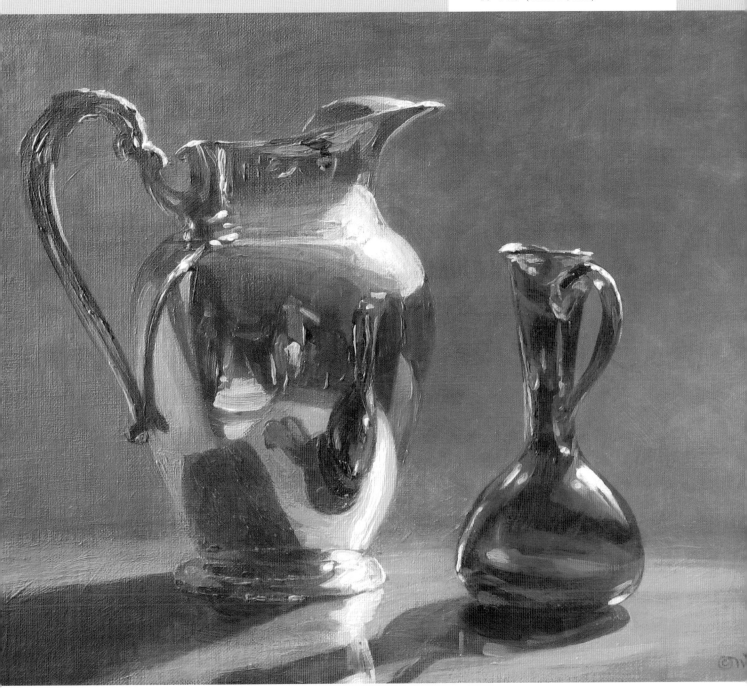

◄ *Metal*

Thick, loose strokes of acrylic create the reflections in the silver pitcher. Viewed up close (at left), parts of the image are teetering on the abstract.

Working wet-into-wet as much as possible with the fast-drying acrylic, I painted the simple shapes of the body of the silver pitcher with a no. 4 flat, a no. 6 bright and a no. 4 filbert using thick strokes. I built up the pigment especially thick on the brightest highlights.

On occasion people ask if I use special silver paint to make things look so reflective. I explain that it's a matter of copying the areas of light and dark and color in the correct relationships to one another, though I'm not sure everyone believes me.

capturing the essence

Your mission is to use dynamically applied paint to capture the viewer's interest and direct his attention. To accomplish this, it's necessary to eliminate much of a scene's distracting detail while also capturing the essence of your subject.

Ask yourself: "How can I boil down the essence of this image into the fewest elements while maintaining a realistic appearance?" The answer involves a three-step thought process:

1. Identify the primary elements that make the image appealing.
2. Simplify the subject by eliminating distracting elements and details.
3. Determine where to place your bold strokes for maximum effect—to suggest detail and to contribute to a dynamic appearance.

Successfully carrying out these three steps requires discipline. When we view an inspiring landscape, or an intriguing person, or a luscious still life, the details swarm over us, demanding our attention. But, since we're dedicated to expressive brushwork, we must look past all the little particulars and focus on what makes the image compelling.

Identify the Primary Elements

The first step is identifying the most striking elements of the subject. What is the main attraction? There are no rules as to what must be brought out; that depends in part on what you want to emphasize. Train yourself to evaluate what is important in the scene even before laying a brush on the canvas.

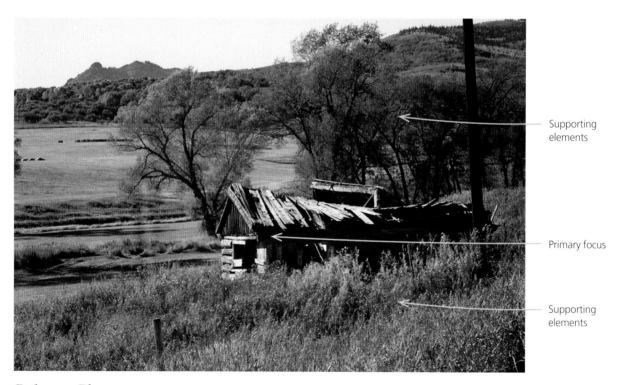

Supporting elements

Primary focus

Supporting elements

Reference Photo

We'll start with an easy one. The cabin obviously comprises the primary focus. Keep in mind, though, that the undulating verticals of the cottonwoods and the foreground grasses are important secondary elements that anchor the cabin in space and accentuate its sense of abandonment and decay. The cabin will be done with impasto strokes to suggest detail, while the trees will be executed with medium-thick paint applied with a softer touch so they don't distract from the collapsing structure. The foreground grasses lend themselves to loose washes and diffused brushwork.

Think of the painting like a movie: Identify which elements are the stars of the show and which serve as the supporting cast. Paint the stars in a way that maximizes their impact, and design the supporting elements so that they contribute to the total effect without upstaging the stars.

Simplify: Eliminate Distracting Elements and Details

Once you've identified the core interest, evaluate the elements that enhance the main attraction and simplify them so they don't distract. Certain elements may have appealing features, but if they detract from your visual goal, get rid of them. Decide ahead of time where to suggest details and where to eliminate them altogether.

Then stick to your guns!

When I was younger, I reveled in the rendering of fine detail—painting every hair, branch and sparkle. It produced a potent sense of accomplishment and was immensely fun in its own way. Over the years, I've come to understand that the tight, realistic approach, though perfect for achieving certain types of impact and feeling, is inadequate for other realms of artistic expression. I've also discovered that learning to simplify and suggest details with bold brushwork is every bit as challenging and satisfying.

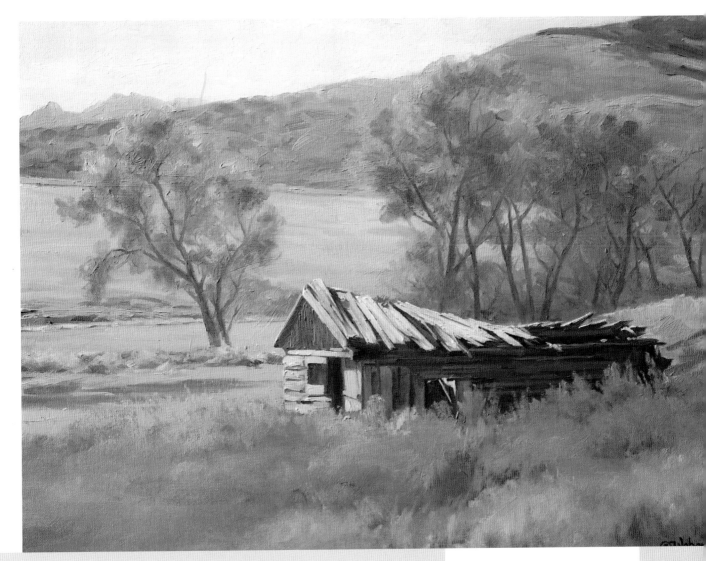

▲ **Seen Better Days**
Oil on canvas on panel
18" × 24" (46cm × 61cm)

Determine Stroke Placement for Maximum Effect

Now it's time to consider how to make the most of bold brushwork. There are two aspects to consider:

1. Make the paint dynamic.
2. Suggest detail.

You want to place your bold strokes in the optimal locations where they add to the drama of your painting. Always keep in mind how the brushwork will affect the entire painting; you don't want to randomly glop on great gushing gobs of goo without considering how it contributes to the whole.

Then think about facets of the scene that lend themselves to flashy and suggestive brushwork. As you look over your subject, pick out items that you can reduce to a series of simple strokes or even a single stroke. It's also important to realize that not every element of the painting's main attraction is a good candidate for impasto paint application.

Generally speaking, I employ the thicker brushstrokes for light areas and some mid-value sections, and only rarely for dark areas. When light illuminates a painting, it sparkles on the ridges of thick paint, and those sparkles show up in an irritating fashion in darkly painted sections.

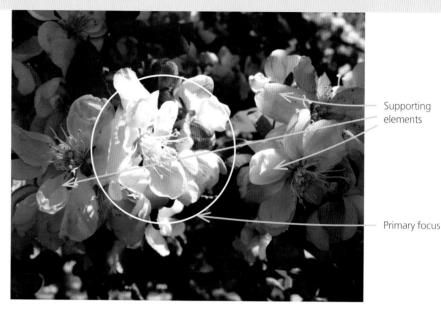

Supporting elements

Primary focus

Reference Photo

The central cluster of blossoms is the star of the show and will require most of the thick brushwork and suggestion of detail. The supporting cast of less prominent petals and leaves should enhance the drama of the primary interest without competing with it. A lot of the detail in the shadow can also be eliminated. The brushwork in these secondary areas can be painted with bold and fluid strokes, but they should be more subdued than the focal blossom cluster.

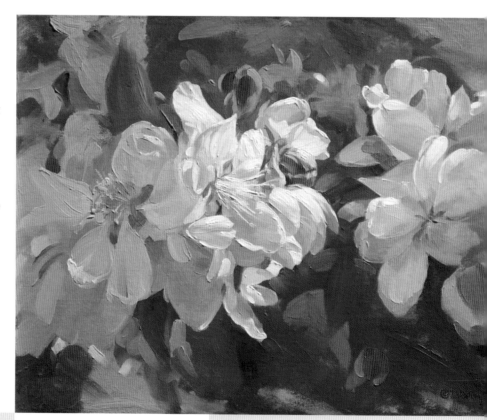

▲ **Blossoms**
Oil on canvas on panel
16" × 20" (41cm × 51cm)

60

▼ Vishnu Temple in the Distance
Oil on canvas on panel
30" × 40" (76cm × 102cm)

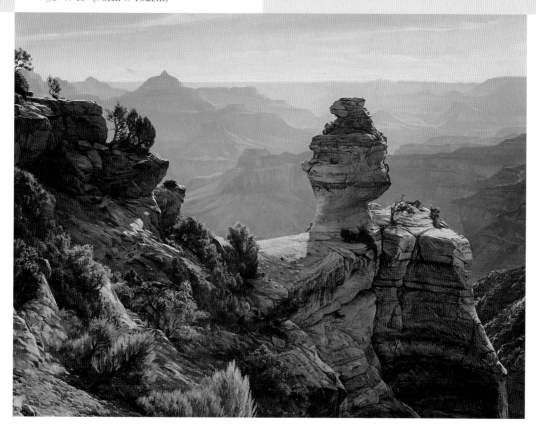

Detailed Approach

The painstakingly rendered detail of this majestic view captures its breathtaking vastness.

But are all the details and days of work on the painting necessary to achieve that sense of grandeur? Not really…

Loose Approach

The impression of distant horizons and the immense chasm is created by values and color, with hazy transitions increasing with distance from the viewer. The loose style softens the harshness of the scene.

In addition, minimizing detail allows other elements to assume more prominence—color, values and large shapes.

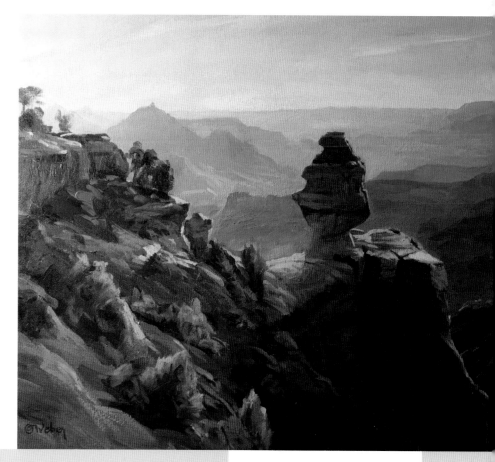

▲ Canyon Morning
Acrylic on canvas on panel
16" × 20" (41cm × 51cm)

Thick but
carefully
applied
strokes

Broad,
fluid
strokes

Reference Photo

It's necessary to resist the temptation to spend days rendering all the enticing architectural detail lurking in this scene. Instead, determine the areas that will give you the most mileage for your brushstrokes.

The stars of the show are the tower and the highlights on the building on the right. You can suggest the structure of the building, the textures of the materials and the detail with thick but controlled brushwork, then loosely suggest the rest with broad, vigorous strokes.

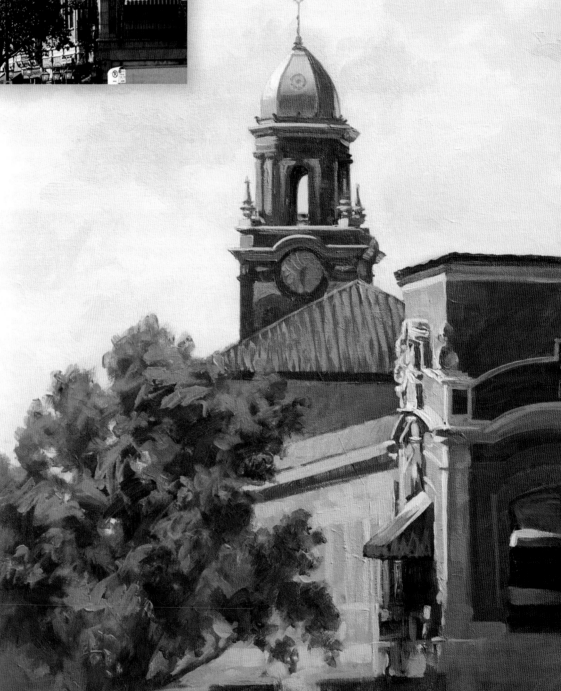

Reference Photo

This subject presents an interesting challenge. Though the woman's striking face is the primary interest, I wanted to paint it with relatively subdued brushwork to retain the refinement of her features. However, the gown's shiny fabrics and the simple masses of the cushions are just begging for some flashy brushwork to bring them to life. The face has enough drama to hold its own, and the bold strokes in the fabrics will serve to enhance it rather than distract.

Bold strokes

enhance the center of interest

The primary focus is not necessarily the area where you will use dramatic brushwork, but you want to use all elements of a painting, including brushwork, to play up the center of interest.

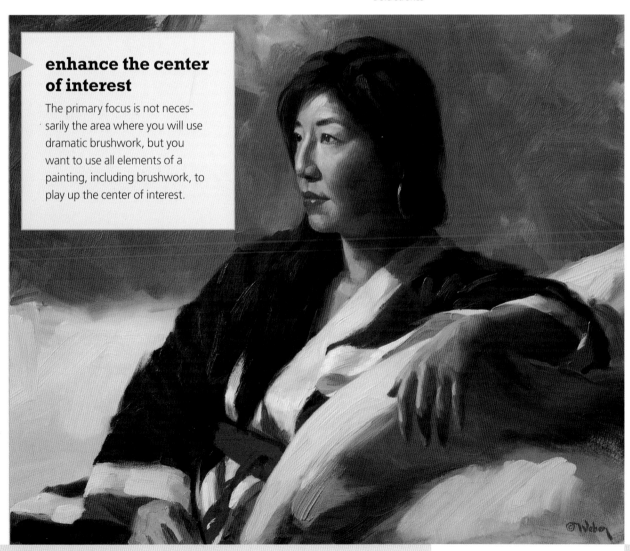

▲ **Time for Reflection**
Oil on canvas
20" × 24" (51cm × 61cm)

n ow you're ready to put all the preceding material into practice. The idea is to limit the number of bold strokes so you can think through each stroke carefully. The exercises begin very simply, using bold strokes in limited areas, then progress by stages until you'll do nearly an entire painting with them.

Remain focused on learning bold brushwork rather than worrying about the artistic quality. Embrace the risk of laying the paint on thickly and decisively, and avoid tentative fussiness. Think of the exercises as a game. Games are supposed to be fun, so approach each exercise with a playful attitude; work in a brisk fashion and move on.

Here are the rules of the game:

exercises
CHAPTER 5

1. Each exercise allows a speci-fied amount of time to establish your drawing and block in your basic shapes. The time limit forces you to focus on the essentials of the picture and keeps you from becoming bogged down in drawing, color, etc. If you find the time I've given is too long, shorten it and move on to the next step.

2. You are allotted a limited number of finishing bold strokes for each exercise. With so few strokes to work with, you must think through the mechanics of each one. For that reason, once you've completed the block-in or have run out of time, you can take as much time for the bold strokes as you want.

3. You may not alter your final strokes in any way. Just like my Uncle Paul's unwavering verdict when playing a heated game of hearts: Down is down. You cannot add to or maneuver your strokes after they're down on the canvas. The only exception is that you may remove an entire stroke with your palette knife if you are dissatisfied with it and try again.

Consider the following when thinking through your bold strokes:

• The most effective places to use them;

• The shapes of the strokes, including thickness;

• How best to load and apply the paint.

In the exercise steps, I've listed the paints for mixtures like packaged foods list ingredients: the first color is the most plentiful, followed by pigments of diminishing proportions.

◀ **The Scythe of Time**
Oil on canvas
20" × 16" (51cm × 41cm)

egret

Take a few minutes to determine the most appealing elements in the image below. Then decide which parts to translate into descriptive, dynamic strokes. The colors and values in the shadow areas are subdued, so the most obvious areas of interest are the highlights on the head and upper body, followed by the orange of the beak and the soft brown plumage in shadow, then the eye and the reflected light under the head. Don't panic about the grass; we're going to ignore the background for the most part and treat it with washes, a very basic block-in and one or two quick strokes.

Remember: What you choose to leave out of your paintings is often as important as what you include.

Materials

Paints *(Holbein Duo Water-Soluble Oils)*
- ▶ Burnt Sienna
- ▶ Cadmium Red Hue
- ▶ Cadmium Yellow Light Hue
- ▶ Naples Yellow
- ▶ Phthalocyanine Blue (Phthalo Blue)
- ▶ Raw Umber
- ▶ Rose Madder
- ▶ Titanium White
- ▶ Ultramarine Light
- ▶ Yellow Ochre

Medium
- ▶ Water-soluble linseed oil

Brushes *(Synthetic Bristles)*
- ▶ Brights: nos. 10, 12
- ▶ Filberts: nos. 4, 6, 8, 12

Specs

Size: 14" × 11" (36cm × 28cm)
Time for drawing and block-in: 1 hour
Bold strokes: 15

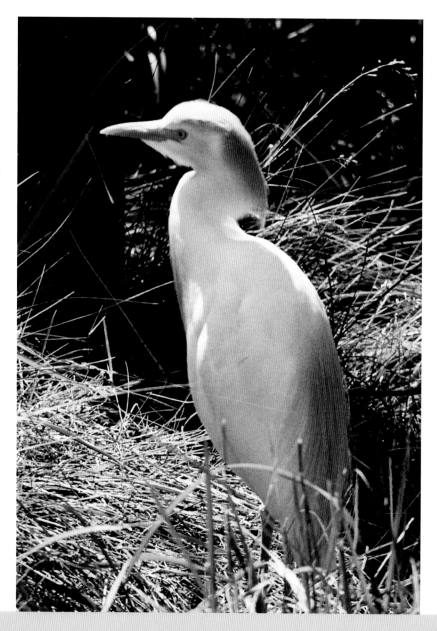

◀ *Reference Photo*
This egret with its elegant profile and strong lighting makes a simple subject. It requires only modest drawing and has limited colors, few values, and very little distracting detail.

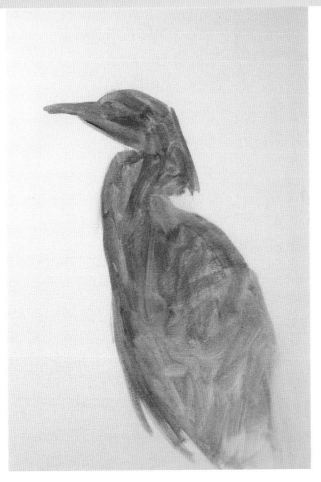

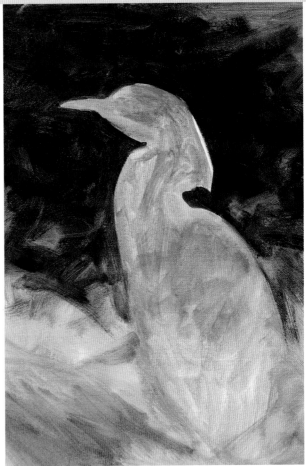

1 *Wash In Subject*

Mix up a wash of Raw Umber with a little Titanium White and thin with water to a #7 consistency. Using a no. 8 filbert, lightly wash in the subject with a simple silhouette.

completely cover canvas

As you apply an initial wash or block-in with opaque paint, fill in all the tiny valleys of the canvas texture so you don't end up with a lot of little white specks in your picture. This often requires scrubbing the initial colors onto the canvas, which is why I use battered brushes (scrub brushes) when I start a painting.

2 *Wash and Block In Background*

Thin Yellow Ochre with water to a #7 consistency and loosely wash in the lower half of the background with a no. 10 bright. Create some variations to imply grass.

For the top half, combine Phthalo Blue, Raw Umber, Yellow Ochre, Titanium White and Cadmium Yellow Light Hue, and apply a wash with the same brush. Scrub some of it down into the Yellow Ochre wash. Then, using the same dark green color, but without water, add just a touch of linseed oil and block in the darker areas of the background.

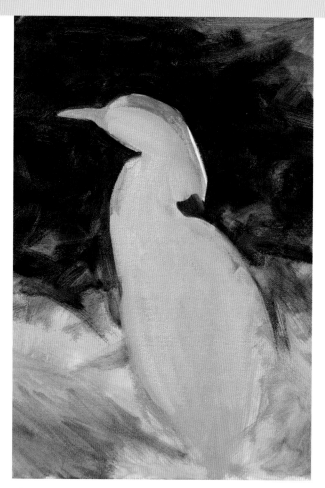

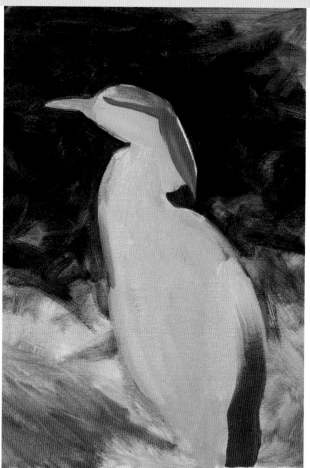

3 *Complete Block-In*

Using a mixture of Titanium White, Ultramarine Light and Raw Umber with a touch of linseed oil, thinly block in the shadow of the egret with a no. 8 filbert. Avoid painting the areas where the highlights and brown plumage will go, because the blue of the shadow will muddy those colors when you apply your final strokes.

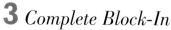

> ### blending strokes
>
> You can quickly and easily create blending in many instances by simply pulling your loaded brush over wet paint. As the pigment gradually runs out, it appears to blend into the paint you're working into.

4 *Paint Brown Feathers* ▶ Strokes 1–3

Mix Raw Umber, Rose Madder and Titanium White, then add linseed oil to create a #3 consistency paint so it will apply fluidly. Tip-pull load a no. 6 filbert with enough pigment to paint the top of the head with one stroke. Using the same brush, but only a touch of paint, do one light stroke for the brown on the lower neck.

For the lower back, body load a no. 12 bright. Because you want the pigment to blend into the blue-gray shadow color at the top of the bird's back, begin your stroke at the bottom and pull up. Start with the brush at a 45-degree angle, and gradually lower it as you pull so the paint plays out in a long stroke.

5 *Paint Body Highlights* ▶ Strokes 4–7

Using a no. 6 filbert, tip-pull load a small amount of a #3-consistency mixture of Titanium White and Ultramarine Light. Begin at the top on all these strokes so that the paint blends into the blue and brown of the shadows as you move downward, like it does in the subject. Because these are long, narrow shapes for the most part, gradually lower the brush as you pull so the paint will last for the entire distance.

tip-pull loading

Pull the tip of a no. 6 filbert through medium-deep paint on your palette to load paint on the bottom ¼" (6mm) of the brush.

tip-pull load ready

Getting the paint on the brush right where you want it enables you to apply the type of stroke you want with precision.

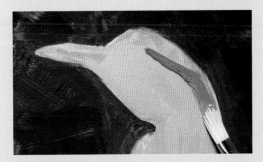

tip-pull-loaded stroke application

Press down when you want the stroke to widen, and lift up a little when you want the stroke to narrow.

To narrow it further, turn the brush edgewise while you continue to pull so that just the thinnest tip of the brush is creating the line.

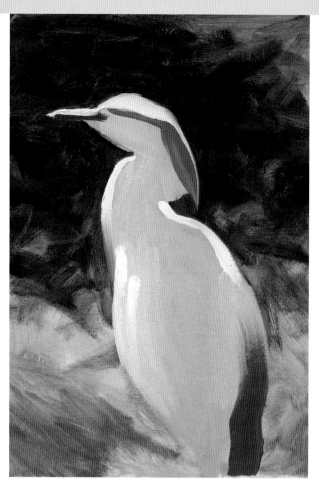

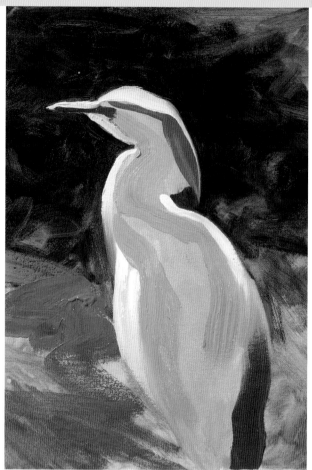

6 *Apply Highlights to the Head*
▶ **Strokes 8–10**

Mix a #3 consistency of Titanium White, Cadmium Yellow Light Hue, Cadmium Red Hue and Burnt Sienna. Tip-pull load a no. 4 filbert and lay down the beak highlight. For the beak shadow, tip-pull load the same brush with a mixture of Cadmium Yellow Light Hue, Cadmium Red Hue and a little Naples Yellow, and apply the horizontal stroke.

For the head highlight, mix Titanium White with a touch of Burnt Sienna to the same consistency. Begin the stroke at the beak, then lower the brush as you go to apply thick paint to the top of the head; as you near the back of the head, lift up the brush and turn it to continue the stroke with a very thin line all the way down to the end.

7 *Finishing Fun* ▶ **Strokes 11–15**

You'll finish the body shadows in two long, juicy strokes, so you'll need to mix up a hefty pile of paint—a slightly darker value of the Titanium White, Ultramarine Light and Raw Umber mixture from step 3, but thinned to a #4 consistency. Body load a no. 12 filbert halfway up the bristles so you can use one stroke to paint the shadow that snakes from the beak down to the lower back. Starting at the beak and gradually lowering the brush as you pull, press down to widen the shape, then ease up and turn the tip to narrow it. Press down again to widen the stroke, then slowly lift up as you approach the end so the color blends in. Do a similar stroke on the left side of the bird's body, starting at the bottom of the neck.

Body load the no.12 filbert from a big pile of Phthalo Blue, Yellow Ochre, Titanium White and Raw Umber of #4 consistency, then apply a single thick stroke between the dark green and ochre background wash. Paint the eye with a no. 4 filbert and just a touch of a Raw Umber, Ultramarine Light and Titanium White mixture. Apply the reflection under the head with a no. 4 filbert tip-pull loaded with a small amount of Titanium White, Ultramarine Light, Naples Yellow and a touch of Raw Umber.

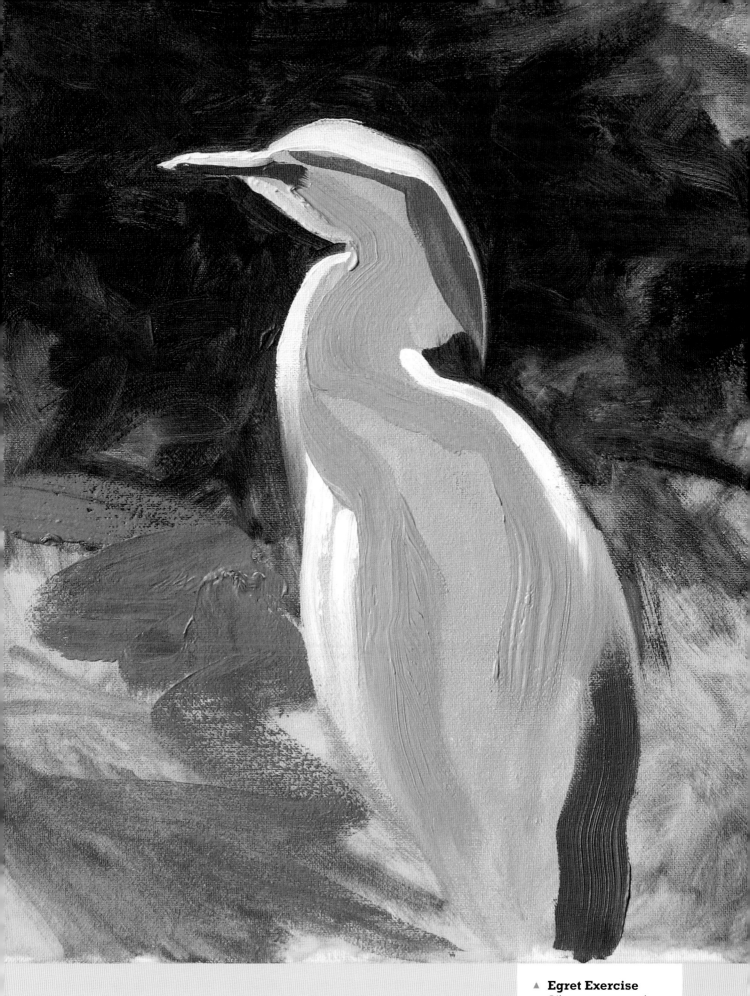

Egret Exercise
Oil on canvas on panel
14" × 11" (36cm × 28cm)

landscape

When working with fast-drying acrylics, you may lament that you can't scoop up a wrong stroke once it's dried. That comes with the territory, and you'll just have to paint over it. Acrylics have a way of forcing you to become more decisive so that you can determine sooner if you've made a mistake and remove strokes while they're still wet.

Before you begin, determine which parts of this are the most appealing, and which can carry the picture. For me it's the central hillock framed by a couple trees with the morning light raking across the rust-colored grass. All the other elements provide the setting and create a sense of depth for the central hill and trees.

Keep the trees that enhance your focal point, and get rid of the others. For the trees you retain, you'll need to sacrifice the detail in them and rely on suggesting the basic shapes. You can also do without some of the subtleties in the shadows and the details of the distant hills.

Materials

Paints *(Liquitex Heavy Body and Super Heavy Body Acrylics)*

- ▶ Burnt Sienna
- ▶ Cadmium Yellow Light Hue
- ▶ Cadmium Yellow Medium Hue
- ▶ Phthalocyanine Blue (Phthalo Blue)
- ▶ Raw Umber
- ▶ Titanium White
- ▶ Ultramarine Blue
- ▶ Yellow Oxide

Brushes *(synthetic bristles)*

- ▶ Filberts: nos. 6, 8, 12

Specs

Size: 12" × 16" (30cm × 41cm)

Time for drawing and block-in: 15–20 minutes

Bold strokes: 15

◀ *Reference Photo*
I came upon this gorgeous view in the Lake District in England, an area that possesses an almost magical beauty and serenity. These gentle hills with the early morning mist and sunshine convey a touch of that spirit.

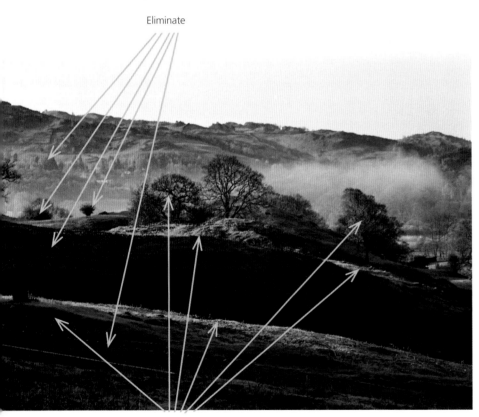

Eliminate

Key strokes

plein air painting with acrylics

Mist your paints more frequently when painting on location. The air exchange is much higher outdoors than in the studio, which causes acrylics to dry much more rapidly.

1 Draw the Scene

The forms are very simple, but for our purposes, simple is good. The key is to correctly sketch the angles of the sloping hills. Next in importance is the relative width of the bands of color.

Right before starting, lightly mist the canvas so the paint will remain fluid longer should you need to wipe out lines and restate them. Use a no. 8 filbert to draw in the basic hill shapes with a #7-consistency Yellow Oxide wash.

(All the pigment used for the remainder of the painting will be unthinned straight from the jar or tube.)

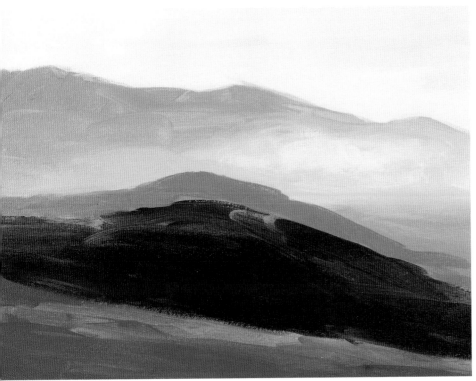

2 Block In the Large Shapes

Paint the sky with a mixture of Titanium White and Ultramarine Blue. Working wet-into-wet, you can blend in darker paint for the sky, and lighter for the clouds.

With a mixture of Ultramarine Blue, Titanium White, Cadmium Yellow Light Hue and Raw Umber, block in the distant mountains. While the paint is still wet, blend in the light mist area.

Mix the medium and dark greens of the middle hillock and the bottom swath from Phthalo Blue, Cadmium Yellow Light Hue, Raw Umber and Titanium White, and brush them in.

With a combination of Burnt Sienna, Yellow Oxide and Raw Umber, apply the rust-colored midground, varying the thickness of the paint to loosely suggest the ground cover texture.

Use a no. 12 filbert for all the blocking-in.

3 Paint Foreground Highlight and Shadow

▶ **Strokes 1–3**

Body load a large amount of dark green mixed from Ultramarine Blue, Raw Umber and Cadmium Yellow Medium Hue onto a no.12 filbert. Gradually draw the brush at a shallow angle across the foreground shadow from left to right, varying the width of the stroke as you progress.

Tip-pull load a modest amount of a mixture of Ultramarine Blue, Cadmium Yellow Light Hue and Titanium White onto a no. 8 filbert, and paint the blue-green stroke in the far right corner of the foreground.

Mix Cadmium Yellow Light Hue, Phthalo Blue and Yellow Oxide, then tip-pull load a medium amount of that color onto a no. 8 filbert. Starting at the far left, paint one long stroke for the streak of sun on the foreground grass.

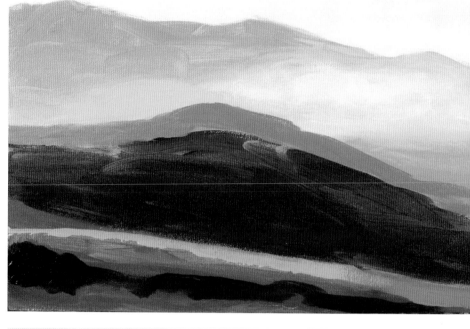

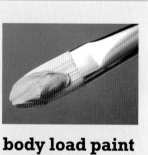

body load paint for hillock highlight

Prepare to paint the highlight on the hillock's crown by body loading a hefty amount of paint onto a no. 12 filbert. It should look similar to the brush pictured here so you'll have enough pigment to lay a thick, light-catching brushstroke on the hillock's crown. The color is a peach-like mixture of Cadmium Yellow Medium Hue, Burnt Sienna and a little Titanium White.

4 Apply the Body-Loaded Stroke ▶ **Stroke 4**

Lightly pull the brush across the canvas at a shallow angle, gradually lowering it so the paint evenly plays out. You want to achieve a thick stroke, so just touch the paint to the surface without pressure. (Pushing down on the brush will flatten and spread out the paint.) As the highlight fades into the shadow, gradually lift the brush so the stroke softly trails off.

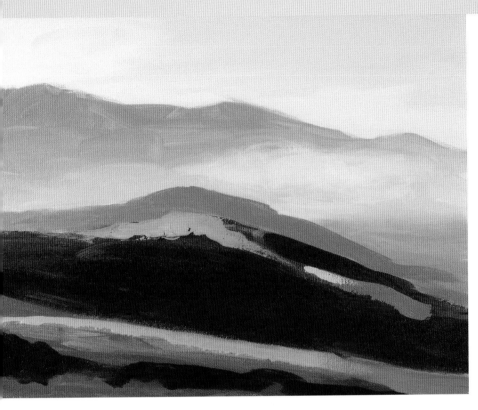

5 *Apply Highlights to the Main Hillock*
▶ Strokes 5–6

You've already applied the peach highlight. Now, mixing a medium-value green from Yellow Oxide and Phthalo Blue, tip-pull load a small amount of pigment onto a no. 8 filbert and apply a stroke, pulling from right to left.

Tip-pull load a very small amount of light green mixed from Cadmium Yellow Light Hue, Yellow Oxide and Phthalo Blue, then gently stroke on the light streak, lifting the brush so the paint gradually peters out into the previous stroke.

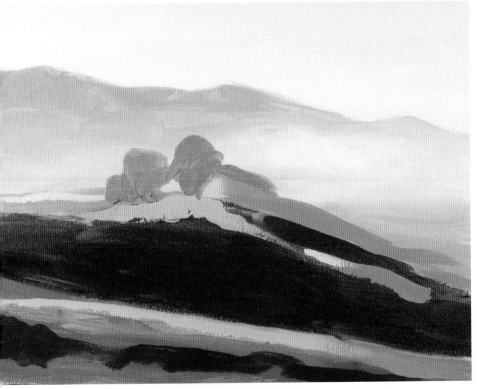

6 *Paint the Green Highlight and Trees*
▶ Strokes 7–8

First paint the green highlight on the next hill back with a mixture of Cadmium Yellow Light Hue, Ultramarine Blue and Titanium White. Tip-pull load a no. 8 filbert, then, starting at the far left, pull along in a thin line and widen the stroke as you approach the hilltop. While that stroke dries, mix up Raw Umber, Yellow Oxide and Titanium White for the central trees. Tip-pull load a medium amount of the mixture with the same brush. Because your strokes are limited, you want to maneuver the brush around without lifting it until you've created the general shapes of the trees on the two central hillocks.

think through the mechanics of each bold stroke

Though some of these strokes that travel back and around, hither and yon, may seem like pointless razzle dazzle, the goal is to teach you to think, think, think about how you want to construct strokes. The process will help you become accustomed to purposefully maneuvering your brushes to achieve whatever result you want.

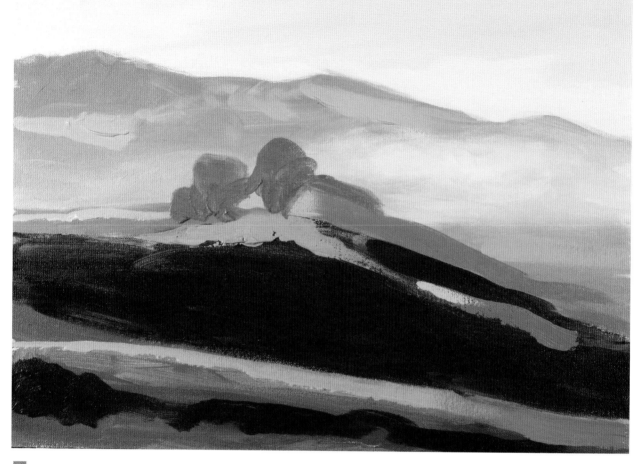

7 *Paint Mountain Highlights and Tan Stripe of Field*

▶ **Strokes 9–10**

Now we're going to get even more outrageous and paint the sunny areas on the distant hills with one stroke. Scan that area and choose the best spots to suggest with paint and devise a simple plan for how to work your way across with one meandering application of paint.

Create a mixture of Cadmium Yellow Light Hue, Ultramarine Blue, Yellow Oxide and Titanium White, then tip-pull load a medium amount onto a no. 8 filbert. Start at the far left, widening or thinning the stroke as you progress according to your plan.

You've earned at least a momentary break, so take a deep breath before going on to the next stroke—a tan streak at the right of the landscape.

Now that you've recovered, mix up of a combination of Titanium White, Yellow Oxide and a touch of Ultramarine Blue. Tip-pull load a small amount onto a no. 8 filbert and apply the paint at a shallow angle, pulling from left to right.

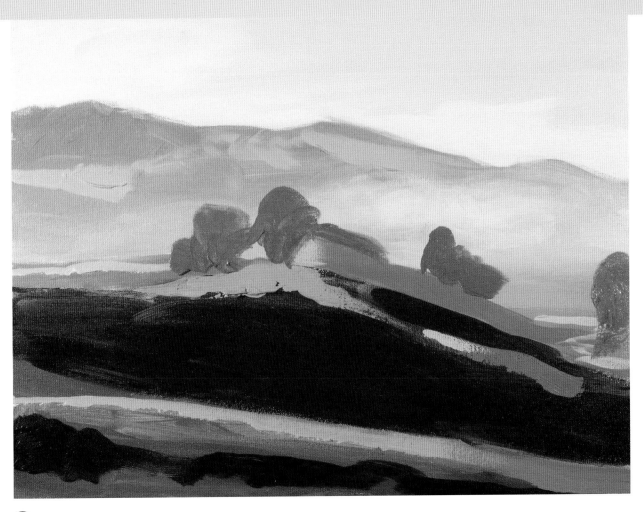

8 *Paint the Light-Green Grass and Remaining Trees*

▶ **Strokes 11–13**

There's a series of light-green areas on the far right middle distance. Use some of the color you made to paint the light green in step 7, and with a no. 6 filbert tip-pull loaded with a small wad of paint, employ one thin, snaking stroke to suggest all those sunlit areas.

Mix an olive green hue from Ultramarine Blue, Cadmium Yellow Light Hue, Raw Umber and Titanium White, then tip-pull load a small amount with a no. 8 filbert and squiggle out the shape of the darkest tree. The final tree on the far right is the same color as the central trees. To suggest it, tip-pull load a medium amount of pigment onto a no. 12 filbert and lay it in with a single stroke.

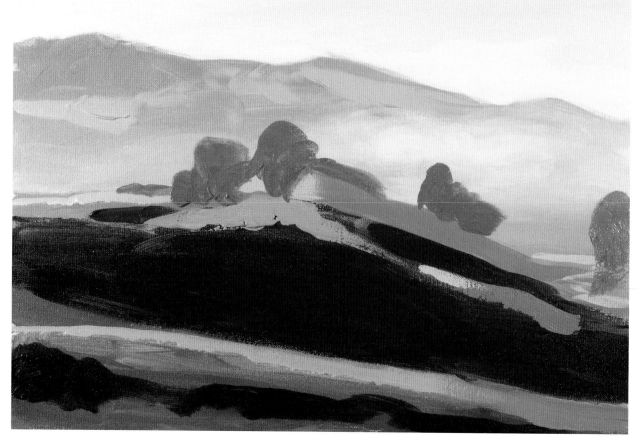

9 *Paint the Final Two Defining Dark Patches* ▶ **Strokes 14–15**

The two little shadowed splotches to the left of the central trees help define the contours of the central hillocks by their dark accents. Use a no. 6 filbert to stroke in both spots, tip-pull loading only a small bit of paint. The darker streak is a combination of Ultramarine Blue, Raw Umber and Cadmium Yellow Light Hue. For the lighter stroke above it, you need to mix only a small amount of pigment from Phthalo Blue, Cadmium Yellow Light Hue, Raw Umber and Titanium White.

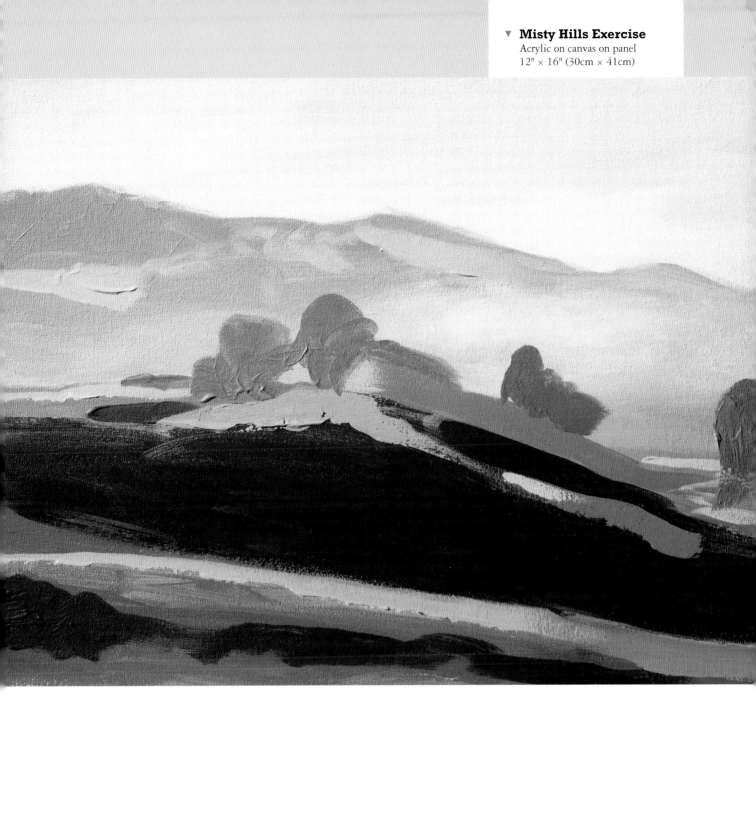

iris

This exercise will give you a chance to use some of the more intense colors on your palette. All the strokes save three are done with the tip-pull load technique, so unless I state otherwise, assume you are to load the paint using that method.

It takes little more than a glance to determine that the most visually compelling aspects of the image below are the frilly, poetic shapes of the petals and their rich violet shadow colors, along with the strong highlights that bring out the flower's form and create drama. You'll want to play up these aspects with the meager fifteen strokes you have at your disposal.

Give the sketchiest possible indication of the background and eliminate the secondary buds. You'll also need to play down the nuances of color and shape in the flower's shadows and rely upon the large forms to carry the image's impact.

Materials

Paints (*Holbein Duo Water-Soluble Oils*)
- ▶ Cadmium Yellow Light Hue
- ▶ Dioxazine Violet
- ▶ Raw Umber
- ▶ Rose Madder
- ▶ Titanium White
- ▶ Ultramarine Light
- ▶ Yellow Ochre

Medium
- ▶ Water-soluble linseed oil

Brushes (*synthetic bristles*)
- ▶ Brights: nos. 8, 10, 12
- ▶ Filberts: nos. 8, 12
- ▶ Flats: nos. 4, 6 , 8

Specs

Size: 16" × 12" (41cm × 30cm)

Time for drawing and block-in: 1 hour

Bold strokes: 15

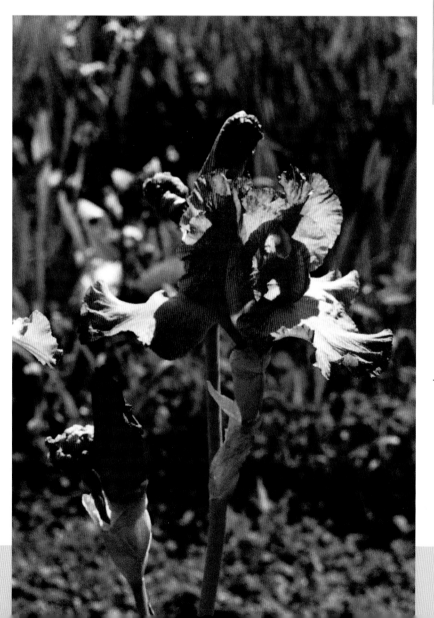

◄ *Reference Photo*
Irises are among my favorite flowers, and this one is a dandy with the crisp, lyrical shapes of its petals and their glowing pink and violet hues. The greens of the background serve to heighten the flower's dramatic colors.

1 Draw the Subject

Using a worn no. 10 bright, sketch the iris with a #7-consistency wash of Rose Madder. Along with the primary outlines, indicate the main shadows.

2 Wash In Background and Flower

Add a little linseed oil to a #6-consistency water-thinned wash of Raw Umber. Use a no. 12 bright to body soak the paint and loosely cover the background, varying the value of the paint as you go. You can wash right over your sketch of the stem. The mixture for the wash on the flower is Rose Madder and Dioxazine Violet applied with a no. 8 bright.

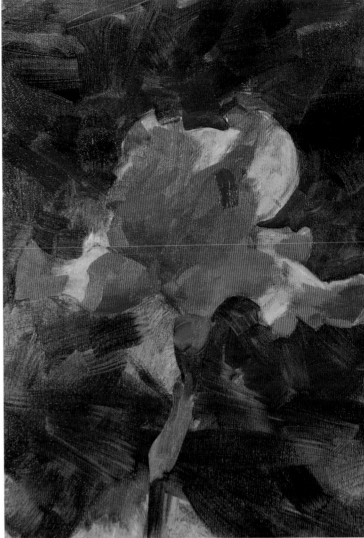

3 *Paint the Background*

Mix a pile of dark green from Ultramarine Light, Raw Umber and Cadmium Yellow Light Hue unthinned with water or linseed oil for the background and the dark spots of the stem. As you loosely work the paint around the background with nos. 8 and 12 brights, play off the umber wash by letting it show through in places. Paint the dark green up to the edges of the flower to define its contours and to accentuate the light on the petals.

4 *Block In the Flower Shadows*

Working with a no. 8 bright, block in the petal shadows with a #1-consistency mixture of Rose Madder, Dioxazine Violet and Titanium White. Don't paint the highlighted areas. Paint the spot of background color between the petals in the upper right section. Then, with a slightly lighter value of the color you used for the stem in step 3, paint the spot where the stem joins the petals. Lower down, paint the papery sheath with a combination of Raw Umber, Titanium White and Yellow Ochre.

chisel-loaded paint for sheath highlight

Borrowing the sunlight gleaming on the sheath of the bud to the left in the reference photo and adding it to your flower will improve the painting. This close-up shows the amount of paint you'll need to chisel load onto a no. 6 flat to paint the highlight in one stroke. The hue is a combination of Titanium White, Cadmium Yellow Light Hue and Ultramarine Light. Add linseed oil to bring the paint to a #5 consistency.

5 Paint the Sheath Highlight
▶ **Stroke 1**

Starting at the top and moving down, maneuver the brush to imitate the basic shape of light on the sheath.

6 Paint the Diagonal Shadow
▶ **Stroke 2**

The dark burgundy shadow that runs diagonally from the petals to the stem is a mixture of Rose Madder, Ultramarine Light and a touch of Yellow Ochre. Mix it to a #2 consistency, and apply the stroke with a no. 6 flat.

7 Paint Right Petal Highlights
▶ **Strokes 3–4**

Now load a mixture of Titanium White and Rose Madder at #2 consistency onto a no. 8 bright, and apply a single stroke that follows the contour of the top of the petal.

Next, loading a modest amount of pigment, paint the lower highlight. Start the stroke thin on the right, then move left, widening the stroke as you go. Then fully widen it, swooping down and to the right to paint the shape of the highlight.

8 Add More Highlights ▶ **Strokes 5–6**

Paint the intermediate value of the curled petal edge bordering the bottom curve of the petal on the lower left with a no. 4 flat. The paint should be a #2-consistency mixture of Rose Madder, Titanium White and Ultramarine Light.

Then, load a medium amount of Titanium White and Rose Madder of the same consistency, and apply a stroke for the other highlight with the same brush.

9 Complete Right Petal Highlights and Glow ▶ **Strokes 7–9**

For the remaining highlight on the right petal, pick up more of the light mixture from step 8 with a no. 8 bright. Start the stroke on the right point of the petal, then draw the brush to the left, widening as you go, until you come to a stop, creating a flat edge. Without lifting the brush, head back to the right, aiming lower and narrowing the stroke as you reach the end.

The color for the top left petal is a mixture of Rose Madder, Titanium White and a touch of Ultramarine Light. Staying with the no. 8 bright, use one stroke to create the shape of the light shining through the petal.

Paint the inverted teardrop-shaped highlight next to the green gap in the flower with a no. 4 flat.

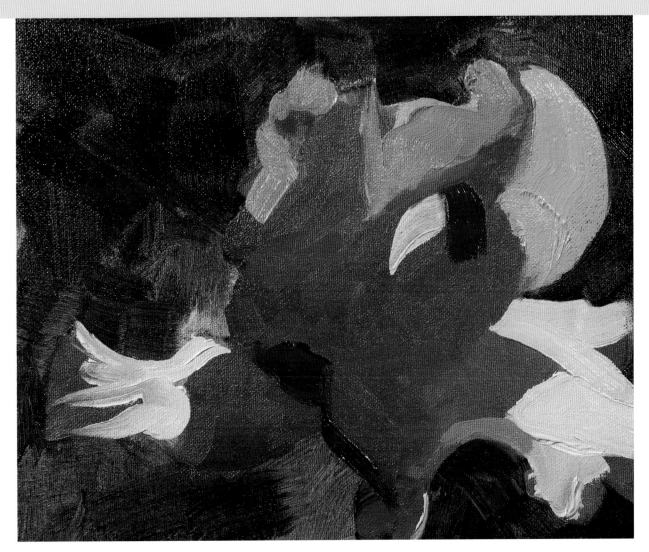

10 *Paint Left Petal Highlights* ▶ **Strokes 10–12**

For the big glowing petal on the upper right, load a no. 12 filbert with a large amount of a slightly lighter mixture of the previous color from step 9. Lay down one big, juicy stroke, swinging the brush around in an arc to create that large shape.

Paint the medium-value glow through the petal on the upper left with one stroke: Start at the top, circle around counter-clockwise, then pull straight down, ending in a square shape.

If you weren't running out of strokes, I wouldn't have you go to this extreme, but the remaining lone area of sunlight on the lower left petal will take a little doing, and we can make it fun in the process. In "real life" painting, you may never make a nutty stroke like this, but my point is to get you to pay close attention to what you're doing with the brush. So, load a medium amount of paint—the same light color used on the first highlights in step 5—onto a no. 8 flat. Start at the right, curve up to the point on the left, then back to the right to define the shape of the shadow. Then, move the brush back and forth to paint the fingers of sunlight illuminating the petal.

practice, not perfection

If you don't like the results of a stroke, remove it and try again. The exercises are designed for learning, not for perfection.

11 *Paint Lights in Shadow and Sheath Highlight*

▶ Strokes 13–15

With only three simple strokes remaining, you're home free now.

For the vertical shape above and a little left of the stem, combine Rose Madder, Titaniuim White and Dioxazine Violet with a touch of linseed oil to make it #2 consistency, and load a medium amount of the pigment onto a no. 8 filbert. Start in the crook of the dark diagonal stroke just above the stem and pull upward, allowing the stroke to narrow a bit and fade out as you end.

The light purple in the shadow to the right is a mixture of Dioxazine Violet, Titanium White and a tiny bit of Rose Madder at the same consistency. Apply the stroke with a no. 8 bright.

I decided to lighten the bit of dry sheath on the left of the stem to make it appear as if it's catching the sun. The mixture is Titanium White with a touch of Yellow Ochre. Apply the stroke with a no. 8 bright. Whew! You're done.

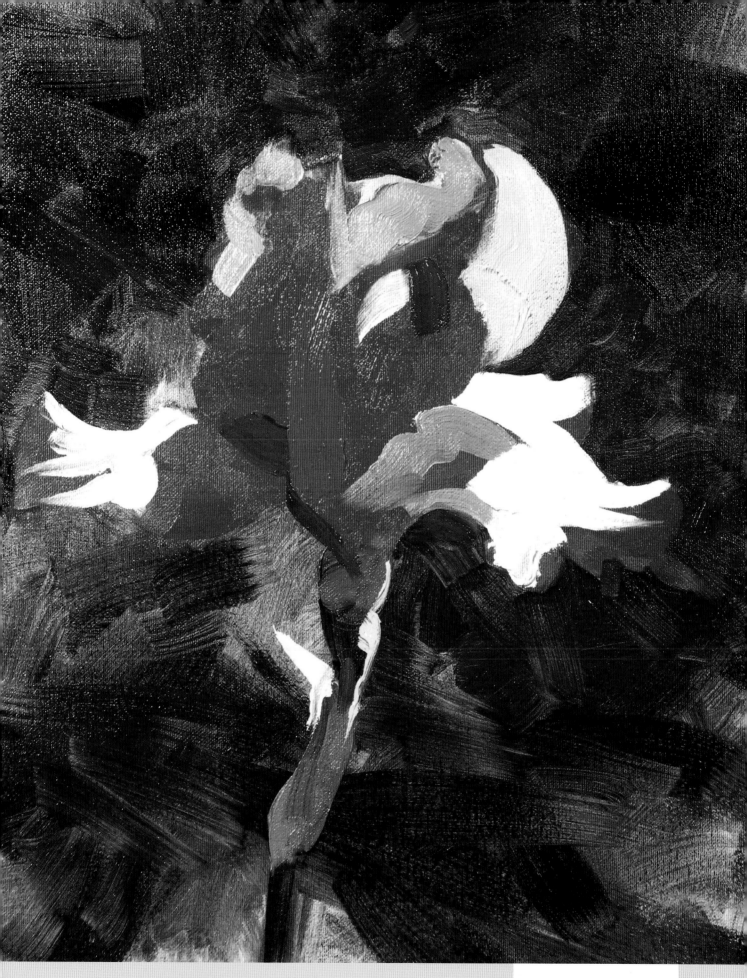

Pink Iris Exercise
Oil on canvas on panel
16" × 12" (41cm × 30cm)

donkey

The interest of the image below lies in the features of the head. Its striking illumination endows the donkey with an almost beatific presence, so you want to focus a number of your strokes to play up this area.

Though the texture of the fur adds appeal, you can't spare strokes to provide detail. However, you can play with the block-in of that section to suggest fur. The saddle is also engaging, but you need to include only the most prominent shapes, then suggest or eliminate less important details. Get rid of the halter, chain and rope because they distract and will use up too many of your precious strokes. And you can do without the flies.

▶ Materials

Paints *(Liquitex Heavy Body and Super Heavy Body Acrylics)*
- ▶ Burnt Sienna
- ▶ Cadmium Red Medium Hue
- ▶ Cadmium Yellow Medium Hue
- ▶ Raw Umber
- ▶ Titanium White
- ▶ Ultramarine Blue
- ▶ Yellow Oxide

Medium
- ▶ Liquitex Glazing Medium

Brushes *(Synthetic Bristles)*
- ▶ Brights: nos. 8, 12
- ▶ Filberts: nos. 6, 8, 12
- ▶ Flat: no. 8

▶ Specs

Size: 16" × 12" (41cm × 30cm)

Time for drawing and block-in: 1 hour

Bold strokes: 28

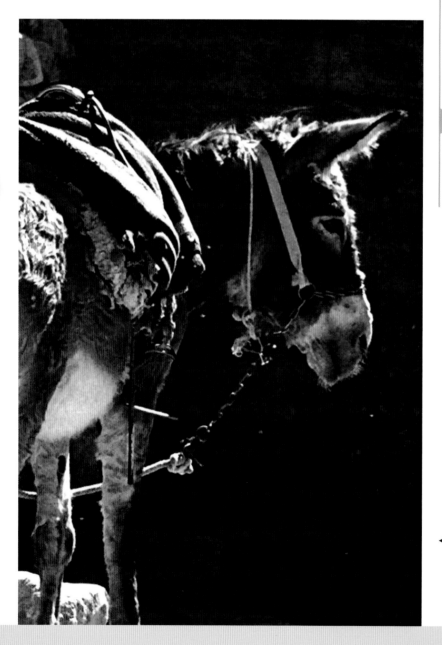

◄ *Reference Photo*
I came across this little donkey at the fabulous ruins of Petra, where Bedouins were charging tourists for rides on their patient beast.

1 Draw the Subject

Use a worn no. 8 bright to sketch the basic image with #6-consistency Burnt Sienna. Pay special attention to the proportions and angles of the head features. Wash in the main shadow areas on the donkey with the Burnt Sienna.

2 Wash In the Background

Mix up a combination of Raw Umber and Yellow Oxide, thinning it to #6 consistency. Wash in the background with a no. 12 bright. Create brushy variations in the wash to make the large plain area more interesting.

mist canvas before painting

When covering large areas with acrylic—whether with a wash or with opaque paint—it helps to mist the canvas right before applying the paint. This keeps the pigment moist longer and will make the surface a little slick so the paint glides on fluidly.

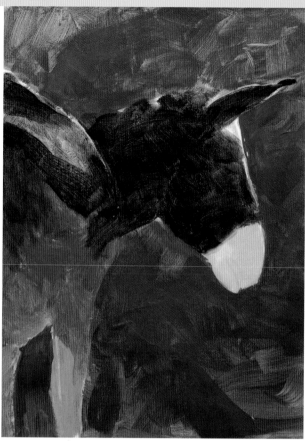

3 *Block In the Donkey*

Use a no. 8 flat and #3-consistency paint to block in the subject. Combine Raw Umber and Ultramarine Blue for the head; Yellow Oxide, Raw Umber, Burnt Sienna and Titanium White for the body. Execute the block-in quickly and loosely, misting regularly so you can do a little wet-into-wet blending as the back transitions from dark to light. Vary the thickness of the paint to suggest the donkey's furry texture.

The saddle is a mixture of Cadmium Red Medium Hue, Ultramarine Blue and a touch of Raw Umber. With the no. 8 flat, paint the entire shape thinly so the canvas shows through for the light area. Then, while it's still wet, quickly dash in the shadows with thicker paint. Mix up a combination of Titanium White, Ultramarine Blue and Raw Umber for the muzzle, and apply it with a no. 6 filbert.

▶ adding gels

Remember that adding gels and mediums to acrylic paint lightens the hue, and the paint will darken noticeably when it dries. Mix up your colors first so you know how they look, *then* add the medium.

4 *Paint the Background* ▶ Strokes 1–3

Adding a muted green to the background will serve to counterbalance the predominant earth colors of the scene. Combine Ultramarine Blue, Cadmium Yellow Medium Hue, Raw Umber and a touch of Titanium White for the background color. Blend in a few drops of glazing medium to make the mixture semi-transparent. The transparency will enable you to create an interesting brushy look that plays off the textures you created with your initial background wash.

Add a little water to bring the mixture to a #4 consistency, then body fill a no. 12 bright with the pigment. Use one continuous, meandering stroke to paint the area above the mane and the saddle. The next stroke is even longer, running all around the head and down to the picture's bottom. Without lifting the brush, paint right up to the edges of the head. Tip-pull load a small amount of paint, and apply one quick vertical stroke between the legs.

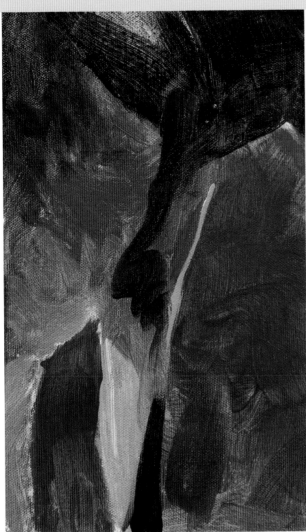

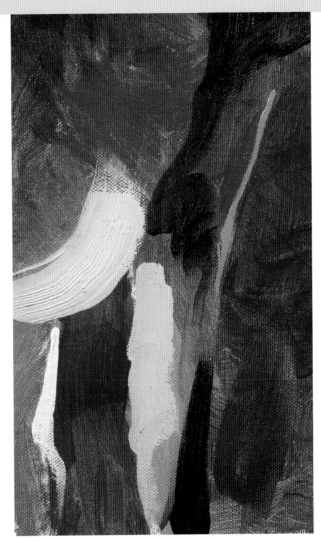

5 *Define Right Leg and Shoulder*

▶ **Strokes 4–6**

Chisel load a small amount of #3-consistency paint mixed from Titanium White, Yellow Oxide and Burnt Sienna onto a no. 8 filbert. With one thin, long line, paint the light line along the shoulder. Next, combine Raw Umber and a bit of Titanium White. Tip-pull load a small wad of paint onto the same brush, and apply the dark area of the knee, starting at the top and widening as you draw the brush down.

With the same color, tip-pull load a larger amount of paint. Starting at the saddle and moving down toward the belly, paint the long and somewhat squiggling dark section that separates the flank from the leg and includes a darker patch of fur.

6 *Paint Light Areas of Belly and Legs* ▶ **Strokes 7–9**

The light of the belly is a #2-consistency mixture of Titanium White, Yellow Oxide, Ultramarine Blue and Raw Umber. Body load a medium amount of paint onto a no. 12 filbert, and apply a single thick stroke at a shallow angle. Mix a small amount of Titanium White with a touch of Yellow Oxide and even less of Ultramarine Blue for the highlight on the left knee. Tip-pull load a no. 6 filbert and lay down the stroke, pulling from top to bottom and varying the width of the shape as needed.

The honey-colored swath on the back of the right leg is an unthinned mixture of Yellow Oxide, Titanium White and Burnt Sienna. Tip-pull load a no. 8 filbert with a medium amount of paint. Starting at the top, maneuver your way down slightly, working the brush back and forth to create an irregular edge in imitation of the donkey's scruffy coat.

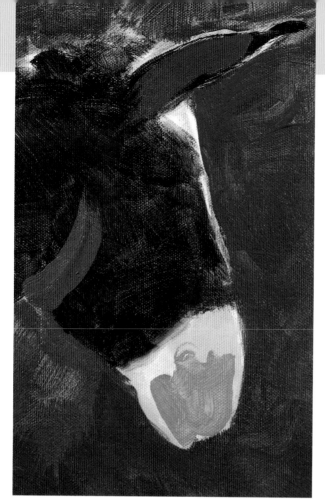

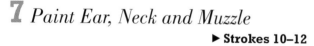

7 *Paint Ear, Neck and Muzzle*

▶ **Strokes 10–12**

The medium-light areas on the ear and neck are made up of #2-consistency Raw Umber with a little Titanium White and Yellow Oxide. Tip-pull load a small amount of paint onto a no. 6 filbert (see photo below). With a single stroke for each, indicate their general shapes.

Mix Raw Umber, Ultramarine Blue and Titanium White for the dark area of the muzzle. Working the paint around with a single stroke, create the general shape of the gray tone. Leave a little edge of the light value along the bottom of the muzzle where reflected light catches the whiskers.

8 *Paint Nostril, Mouth and Neck*

▶ **Strokes 13–15**

These three strokes require only very small amounts of tip-pull loaded paint. Use a mixture of Raw Umber, Ultramarine Blue and a bit of Titanium White for the nostril and mouth; apply with a no. 6 filbert. Combine Yellow Oxide, Titanium White and Raw Umber for the light spot on the neck, and apply the pigment with a no. 8 filbert, pulling up and letting the stroke jaggedly fade into the previous color.

a little paint does the trick

Loaded with the tip-pull method, this small amount of paint is all you need for the three strokes on the donkey's ear, neck and muzzle in step 7.

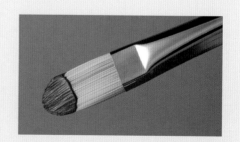

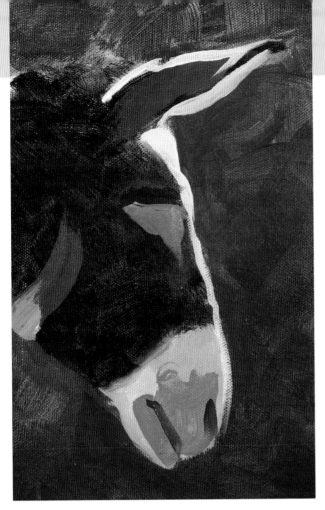

9 *Paint Eye Patch, Ear and Face Highlights* ▶ **Strokes 16–19**

For the top highlight of the ear and down the length of the forehead and muzzle, mix up a small amount of Titanium White with a touch of Cadmium Yellow Medium Hue. Tip-pull load a small bit of pigment onto a no. 6 filbert to paint the highlight on top of the ear. Starting at the ear's base on the left, angle along the edge until you reach the tip, then slant back down along the bottom of the ear and gradually lift your brush so the shape narrows to a point.

For the forehead and muzzle, use the same brush to tip-pull load a small amount of the same color. Holding the brush at a medium angle, begin just below the ear with a wide stroke, then narrow it and follow the muzzle contour down to the nose, carefully delineating the highlight and varying the thickness of the line as needed. Add Yellow Oxide to your mixture and use the same brush to paint the light area of the ear opening with a single stroke.

The strategy for painting the eye begins with mixing Raw Umber, Yellow Oxide and Titanium White. Then, with the same no. 6 filbert, apply a single shape that represents the light area bordering the eye. For the moment, don't worry about the eye itself.

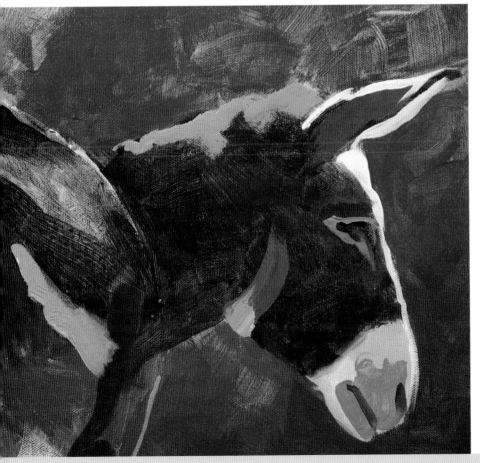

10 *Paint the Eye, Mane and Wool Pad*

▶ **Strokes 20–22**

Tip-pull load a very small amount of a Raw Umber and Ultramarine Blue mixture onto a no. 6 filbert to paint the eye shape. Think of it as a shape, not an eye, and simply copy the general shape without giving any thought to detail.

Combine Titanium White, Ultramarine Blue and a touch of Raw Umber for the highlight on the mane. Tip-pull load a medium amount onto a no. 8 filbert, then pull the brush along at a shallow angle, raggedly going over the areas of light hitting the mane.

The woolly pad under the saddle is a mixture of Raw Umber, Titanium White and Yellow Oxide. Tip-pull load a medium amount onto a no. 8 filbert, and thickly apply a slightly undulating stroke.

11 *Paint Saddle Highlights* ▶ **Strokes 23–25**

The strong crescent shapes of the saddle can be rendered with a couple of strokes, though you want to leave some of the light purple showing at the bottom edges of the highlights as a transitional color.

Mix up a warm hue from Titanium White, Burnt Sienna and a bit of Yellow Oxide, and tip-pull load the #2-consistency paint onto a no. 6 filbert. Paint a long, thin line on the top crescent, and paint the largest highlight starting at the left and moving down diagonally toward the muzzle. Then, without lifting the brush, arc back up to the left to complete the stroke.

Apply a tan combination of Yellow Oxide, Burnt Sienna and Titanium White for the final saddle stroke, using a no. 6 filbert to create a squiggly shape that suggests the miscellaneous highlights on the saddle forms.

12 *Paint Mane Highlights and Dark Ear Edges* ▶ **Strokes 26–28**

Brush on two light splotches with a no. 6 filbert to complete the highlights on the mane—one cool and one warm. The ear will come across a lot crisper if you define its dark borders more clearly. Tip-pull load the same brush with a dark mixture of Ultramarine Blue and Raw Umber, then outline the edges of the ear—top and bottom with one long stroke.

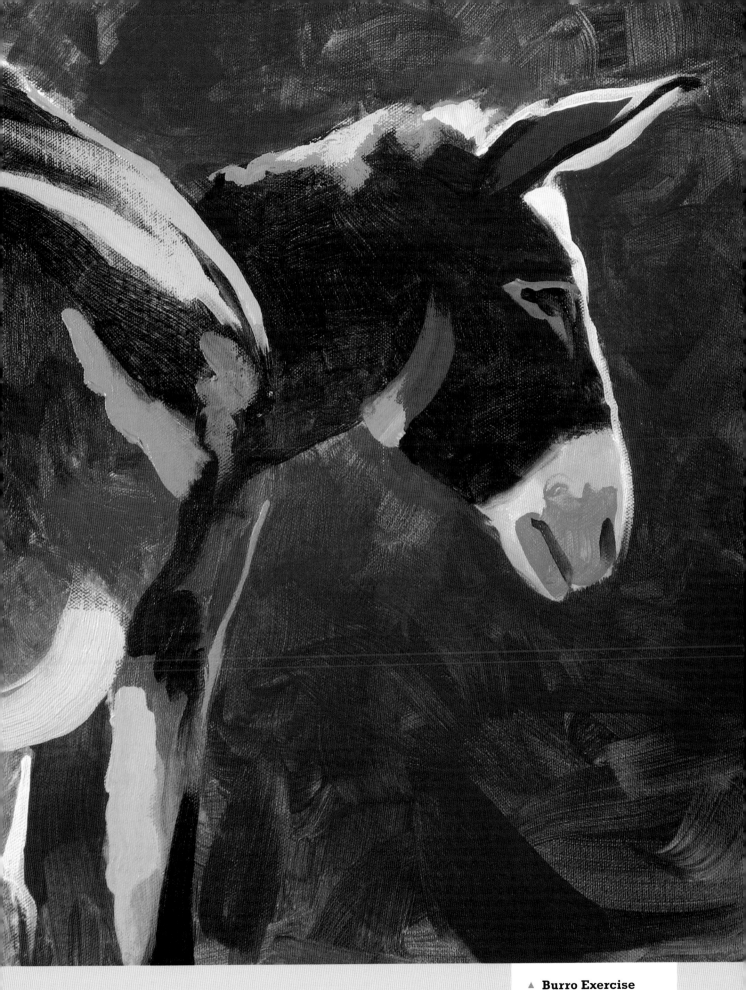

Burro Exercise
Acrylic on canvas on panel
16" × 12" (41cm × 30cm)

portrait

For this portrait exercise, concentrate your attention on the facial features. Most of the drama in the photograph below is created by light raking across the face, which reveals the planes of the features and brings out the eyes, nose and mouth. Although impressive, the silver hair is of secondary importance to the face, as are the shapes in the shirt.

Thirty-five strokes is more than you've had to work with up to this point, but there are a lot of elements to define in the structure of the face, so you'll need to make economical use of the strokes. For the hair and the shirt, pick out the most essential shapes and use the fewest possible bold strokes to state them and at the same time suggest texture.

Materials

Paints *(Holbein Duo Water-Soluble Oils)*
- ► Burnt Sienna
- ► Cadmium Red Hue
- ► Cadmium Yellow Hue
- ► Raw Umber
- ► Rose Madder
- ► Titanium White
- ► Ultramarine Light
- ► Yellow Ochre

Medium
- ► Water-soluble linseed oil

Brushes *(synthetic bristles)*
- ► Brights: nos. 8, 10, 12
- ► Filberts: nos. 2, 4, 6, 8,

1½" (38mm) house brush *(natural or synthetic)*

Specs

Size: 18" × 14" (46cm × 36cm)

Time for drawing and block-in: 1½ hours

Bold strokes: I'm giving you 35 for this one, because bringing out the features of the face with so few strokes will prove challenging (and I'm also feeling uncharacteristically generous).

96

◄ *Reference Photo*
My friend Bill did a wonderful job modeling for this portrait. It's great to work with someone who can follow detailed instructions to make all the subtle adjustments in pose, posture and expression needed for a portrait and then hold them.

1 *Draw the Figure*

Thin Burnt Sienna with water to #6 consistency, and use a no. 8 bright to sketch the basic drawing. Because this is a portrait, take extra care with your drawing and measuring to get the proportions and angles accurate.

2 *Wash In the Background and Dark Areas*

With more of the mixture from step 1, wash in the darker areas with a no. 10 bright. I often like to do a value wash to give me an idea of how the shapes and values are working out and how the painting as a whole balances. You can also play off of the color of the wash later, allowing it to show through in places.

water-soluble oil washes

When creating a wash that you intend to have showing in the final painting, add a little bit of linseed oil to the paint and water mixture to help bond the pigment to the canvas.

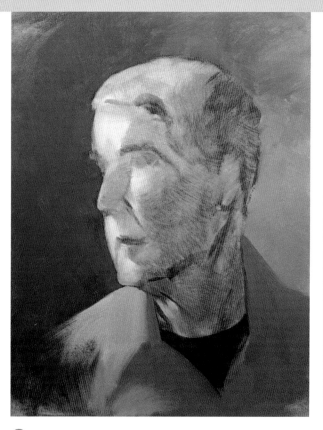

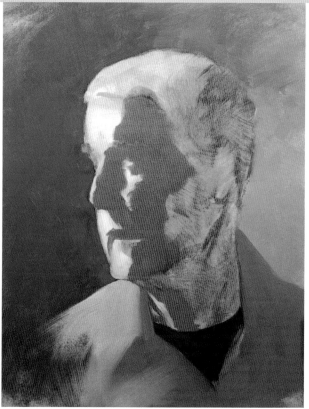

3 *Block In the Background and Shirt*

Use a 1½" (38mm) house brush for the background. Should you feel the need, you can drop down to a no. 8 bright for more careful handling along the edges of the face. Mix Ultramarine Light and Burnt Sienna with a little Titanium White, then add a bit of linseed oil to make the paint #2 consistency. In the process of blocking in this area, allow some of the Burnt Sienna wash to show through in places to give a bit of color variety.

You can create a more three-dimensional effect by making the back of the head appear as dark against light. To this end, lighten the area behind the head by adding more Titanium White and a touch extra of Ultramarine Light to your previous mixture.

Note that I didn't paint over the wash of the left eyebrow. This will come into play later.

For the colors of the shirt, use the same colors as the background but with a higher proportion of Burnt Sienna for a warmer hue (and Titanium White, of course, where it needs to be lighter).

4 *Block In the Transitional Color of the Face*

With a mixture of Rose Madder, Titanium White and Yellow Ochre cooled with a touch of Ultramarine Light, use a no. 10 bright to paint the transitional color of the face, the area where the shadow is lighter and warmer.

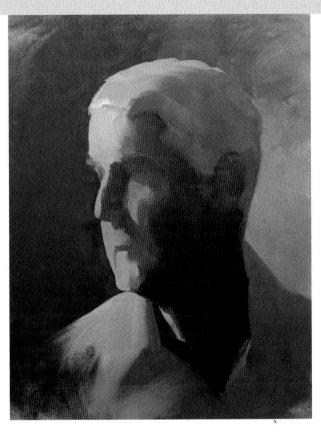

5 *Block In Shadows and Light Areas of the Face and Hair*

Because of the subtleties of the subject, we can allow for a bit more elaborate block-in with a couple additional values to make it easier on ourselves. For the shadows, combine Burnt Sienna, Ultramarine Light, Cadmium Red Hue and Titanium White, and apply the mixture with a no. 8 bright. Blend it into the edges of the transitional color.

Paint the color onto the shadow of the nose, leaving just the transitional color showing at the edges. Darken the shadow color a little with a touch extra of Raw Umber and Ultramarine Light; suggest the jaw shadow by blending in the darker color with a no. 12 bright. Paint the face's lighted areas with a combination of mostly Titanium White with equal parts of a little Cadmium Red Hue and Cadmium Yellow Hue. Leave the washed-in area around the left eye unaltered; this is good enough for an intermediate value.

The hair can be painted in two tones—darker and lighter mixtures of Ultramarine Light, Raw Umber and Titanium White. Apply the paint with a no. 12 bright. Leave the area where the lightest hair runs up to the forehead unpainted.

6 *Paint Highlights on the Left Cheek* ▶ **Strokes 1–4**

Four simple strokes can adequately represent the light hitting the flesh on the left cheek. Use a mixture of Titanium White with small amounts of Cadmium Red Hue and Cadmium Yellow Hue. Applying the paint with a no. 6 filbert automatically creates the rounded shapes of the pouch under the eye.

7 *Paint Eyebrows, Irises and Nostril* ▶ **Strokes 5–10**

For the eyebrows, combine Ultramarine Light, Raw Umber and Titanium White, and make the strokes with a no. 4 filbert. Leave the wash showing on the edge of the subject's right eyebrow so that it appears the light is catching it. In this way you've gone directly from the wash to finishing strokes. On the left eyebrow, notice how the filbert's rounded tip automatically creates the curved shape.

Now for the irises: a simple stroke for each with a no. 2 filbert will do the trick. Use a mixture of Ultramarine Light and Yellow Ochre to make the hazel color of the eyes.

For the nostril itself, mix Burnt Sienna with Ultramarine Light lightened with a touch of Titanium White; apply the paint with a no. 2 filbert. The shadow circling the corner of the nostril is a slightly warmer and lighter mixture of the same color, so add a little Burnt Sienna and Yellow Ochre. Paint the semicircular shadow with the same no. 2 filbert.

8 *Complete the Eyes* ▶ **Strokes 11–18**

The white area of the subject's left eye is basically the same color you used for the light on the hair in step 5. Chisel load a no. 4 filbert with a very small amount of pigment and carefully paint the stroke. Combine Titanium White with a touch of Ultramarine Light for the highlights of the eyes; chisel load just a touch of paint onto a no. 2 filbert, then apply the sparkle in each eye. The light around the folds of the left eye is a mixture of Rose Madder, Yellow Ochre and Titanium White; apply the two strokes with a no. 4 filbert.

The two touches of light paint around Bill's right eye are a very light mixture of Titanium White, Cadmium Red Hue and Cadmium Yellow Hue. Chisel load a small bit of paint, and apply these two small strokes with the same no. 2 filbert you used for the eye sparkles. Then apply a long stroke with the same pigment using a no. 6 filbert for the highlight running down the nose.

tip-pull loaded paint for nose highlight

This is the amount of pigment you should load onto a no. 6 filbert to paint the highlight on the nose in step 8.

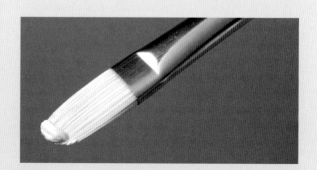

9 *Begin the Mouth* ▶ Strokes 19–22

Continuing to employ the no. 6 filbert, load the same color you used for the nose highlight. Then, starting just under the nose and pulling down, paint two strokes on the right cheek. Next, paint a J-shaped stroke in the center of the upper lip.

For the medium value of the pinkish lower lip, mix Titanium White, Cadmium Red Hue and a touch of Cadmium Yellow Hue, then apply one horizontal stroke with the same brush.

10 *Complete the Mouth* ▶ Strokes 23–27

For the lightest part of the lower lip, create an even lighter mixture of Titanium White with only a little Cadmium Red Hue and even less Cadmium Yellow Hue. Apply the paint in a tadpole-like shape with a no. 6 filbert. Allow some of the medium color you previously painted on the lip to show on the right and bottom.

Next, mix up a small bit of Rose Madder, Yellow Ochre, Ultramarine Light and Titanium White for the shadow of the mouth, and use the same brush to create the darkest parts of the mouth.

The shadow below the lower left corner of the mouth is a combination of Burnt Sienna, Titanium White and a little Ultramarine Light. Stroke it on with the same no. 6 filbert. The shadow on the upper lip is the same color as the previous stroke but with a little extra Ultramarine Light to gray it, as well as a little more Titanium White. Apply this stroke with a no. 6 bright, starting at the lip and pulling up. Gradually lift as you prepare to end the stroke so that it blends out.

Using the same light color you mixed for the light areas of the right cheek in step 9, load a no. 6 filbert. Starting at the center below the lower lip, paint a thin horizontal line along the bottom of the lip, moving left. When you reach the crease, pull down and gradually increase pressure on the brush to widen the stroke as it approaches the bottom of the chin.

11 *Give Dimension to the Neck and Collar* ▶ Strokes 28–31

The highlight on the neck is mixed from Titanium White, Cadmium Red Hue and Cadmium Yellow Hue. This is going to be one of the last back-and-around strokes you use, so load a larger amount onto the no. 6 filbert than you've been using for the smaller strokes. Start at the upper far left, then pull down gradually, lowering the brush as you need more paint for the highlight. Once you've reached the t-shirt—and without lifting the brush—pull up and move slightly to the right; then angle left and up, then right and down into the shadow of the neck.

For the light of the collar, combine Titanium White with a little Raw Umber and Ultramarine Light. Body load a medium amount of the pigment and, starting at the bottom, pull up, angling to the right. Gradually lower the brush to allow the paint to play out. Lift slowly at the end so the stroke blends into the darker body of the shirt.

For the jaw shadow, create a mixture of Burnt Sienna with a little Ultramarine Light and Titanium White. Body load a no. 8 filbert with enough of the pigment to last from the chin all the way to the ear. Apply the paint using the same technique as the previous stroke. Since the width varies along its course, push down when you want to widen the stroke, and reduce pressure to narrow it. You don't want this stroke to be too thick because the grooves and globs will make light reflections, drawing unwanted attention to a feature that needs to remain subdued.

To distinguish between the collar and the back of the neck, use a no. 6 filbert to apply a stroke of dark gray mixed from Raw Umber, Ultramarine Light and a touch of Titanium White. Begin the stroke at the top of the collar, and let it trail off along the neck.

12 *Complete the Ear and Hair* ▶ Strokes 32–35

For the ear, use the same color you just mixed for the jaw shadow. Load a small amount onto a no. 8 filbert; then, starting very narrowly at the upper curve, pull down and squiggle and widen in a fashion that imitates the basic shapes of the shadows of the ear. Then narrow and finish off by curling gently around the ear lobe.

Mix up a medium-light combination of Titanium White, Ultramarine Light and Raw Umber. Load a substantial amount onto a 1½" (38mm) house brush and paint the upper light gray of the hair, starting at the left and working to the right. (Don't paint the area where the lightest stroke goes adjacent to the forehead.) With a no. 8 filbert, load some of the light gray and paint the hair that arcs down to the left temple. When you start to angle toward the ear, gradually begin lifting the brush so the paint fades out.

Combine Titanium White with a touch of the light gray for your final stroke. Body load a medium wad of paint onto the no. 8 filbert, and apply it moving from left to right with a gentle wave to imitate the flow of the hair. Gradually lower the brush as you go, and ease up on it as you merge into the previous stroke.

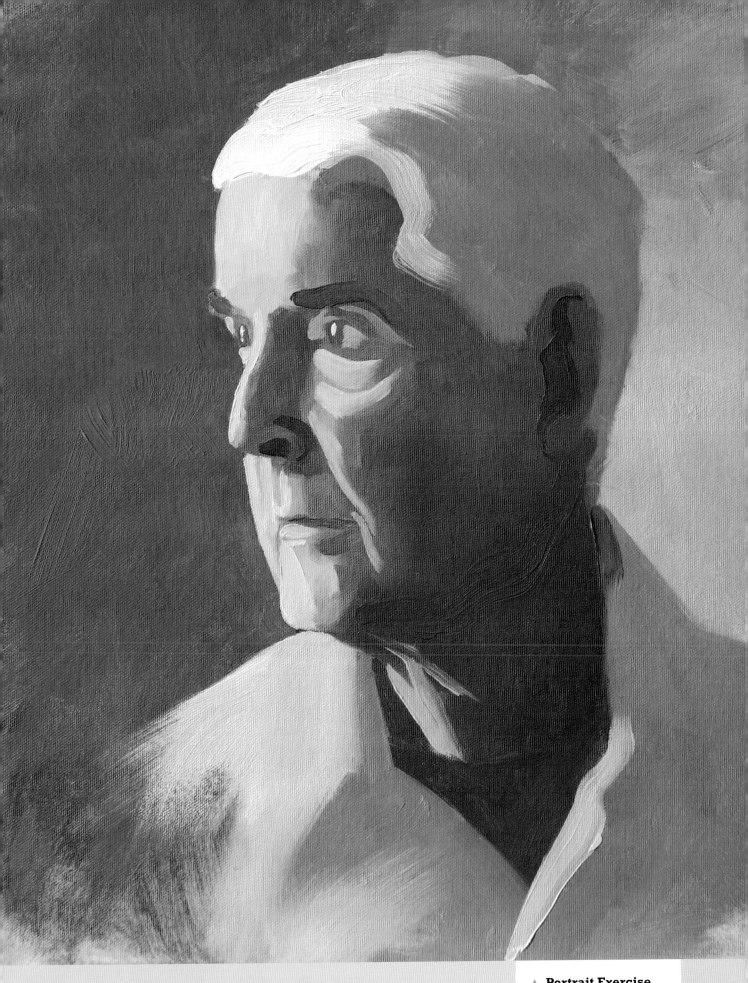

seascape

hat stands out to you in the scene below? For me, the rock first attracts my attention, followed by the waves rushing toward it and all the intersecting variations of foam, water, highlights and shadow. The rest of the ocean and the distant shoulder of land serve to frame the action.

The bright wet sheen on the boulder helps define its form, but the shape is so simple you can paint it with a bare minimum of strokes. You want to use the lion's share of your bold brushwork to heighten the impression of motion in the water. Using the thickest paint in the foreground will make that area appear nearer, adding to the illusion of depth.

▶ Materials

Paints *(Holbein Duo Water-Soluble Oils)*
- ▶ Burnt Sienna
- ▶ Cadmium Yellow Hue
- ▶ Naples Yellow
- ▶ Payne's Grey
- ▶ Phthalocyanine Blue (Phthalo Blue)
- ▶ Raw Umber
- ▶ Rose Madder
- ▶ Titanium White
- ▶ Ultramarine Light
- ▶ Yellow Ochre

Brushes *(synthetic bristles)*
- ▶ Brights: nos. 8, 10, 12
- ▶ Filberts: nos. 8, 10, 12

1½" (38mm) house brush *(natural or synthetic)*

▶ Specs

Size: 12" × 16" (30cm × 41cm)

Time for drawing and block-in: 30 minutes

Bold strokes: 35

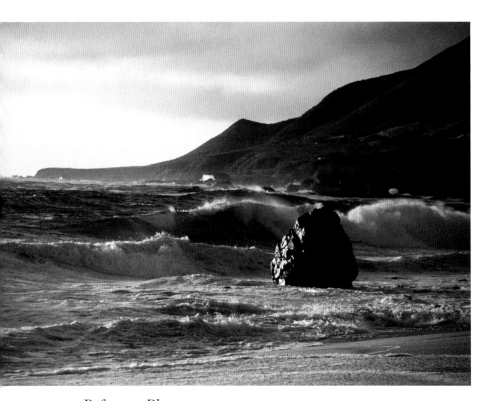

▲ *Reference Photo*
I love the visual dynamics of seascapes: the emerald glow created by the late afternoon sunlight piercing the breakers, the frothy highlights dancing atop cresting waves, and foam hissing over the sand.

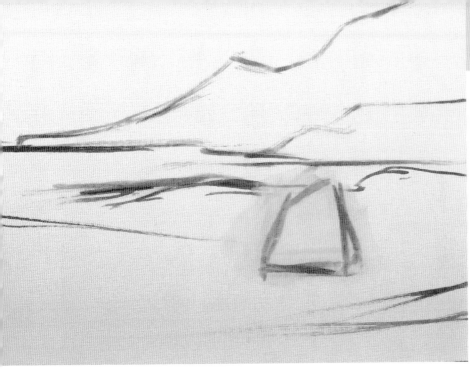

1 Draw the Scene

Using a no. 8 bright, sketch the basic shapes with a wash of Rose Madder thinned with water to #6 consistency.

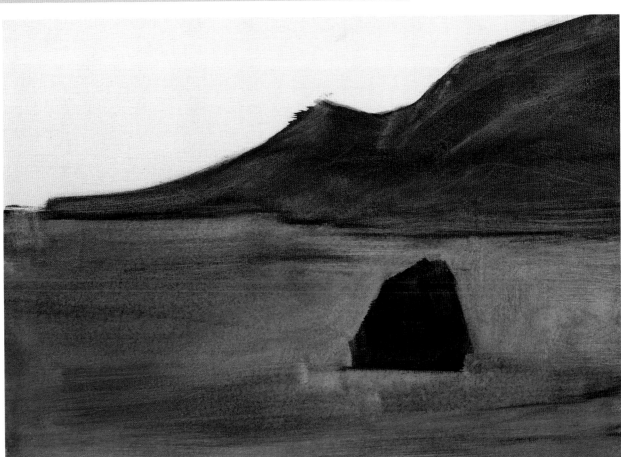

2 Wash In the Rock and Background

Create a mixture of Raw Umber and Yellow Ochre thinned with water to a #6-consistency wash and loosely brush it onto the distant shoulder of land with a 1½" (38mm) house brush. The water is Ultramarine Light with a touch of Yellow Ochre thinned to the same consistency and washed in with the same brush. Use a no. 12 bright to brush in the rock with an equally thin wash of Raw Umber. There's no need to wash in the sky.

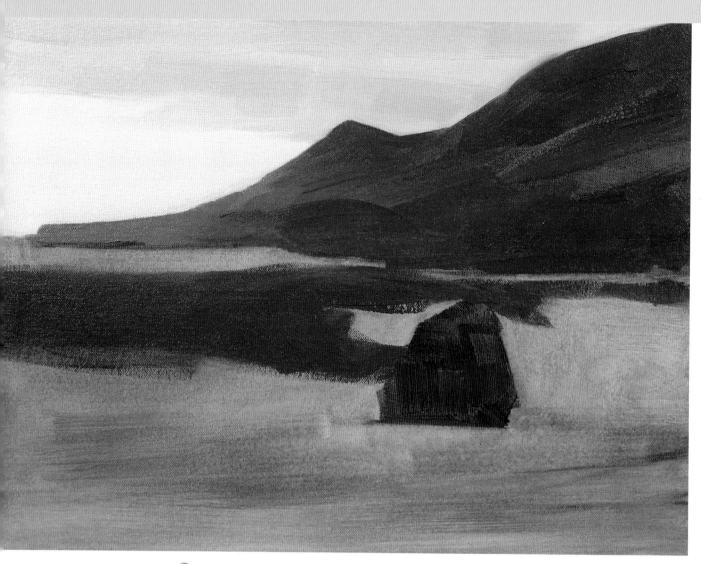

3 Block In the Sky, Land and Distant Water

The lower half of the sky is a light mixture of mostly Titanium White with a little bit of Phthalo Blue. Paint it in with a no. 12 bright. Then mix Titanium White with Ultramarine Light and Payne's Grey, and apply the clouds at the top half of the sky with a no. 12 bright.

The greens of the land can be painted in two tones. For the darker value, combine Ultramarine Light, Cadmium Yellow Hue, Raw Umber and a little Titanium White. As you paint this in with a no. 12 bright, allow the brown wash to show through in places for the light areas on the slopes. The haze of distance causes the far left arm of the land and the land bordering the water to appear lighter; for this, add extra Titanium White and Ultramarine Light to the previous color and apply the paint with the same brush.

For the gray-green of the middle section of water, mix Ultramarine Light with a little Titanium White and a touch of both Raw Umber and Cadmium Yellow Hue. Apply it with the same brush and leave a ½" (12mm) strip unpainted between the dark water and the edge of the land. You'll be painting this with lighter hues, and it will be easier to keep those long strokes of colors clean if you don't have to plow through a heavy mass of a darker pigment.

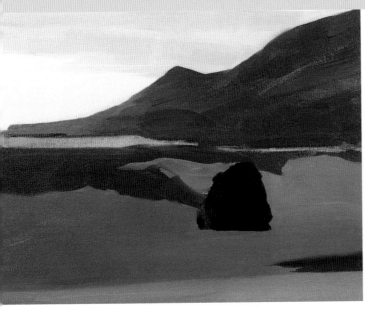

4 Block In the Foamy Area

After making a mixture of Titanium White, Phthalo Blue, Ultramarine Light and Cadmium Yellow Hue, paint the main foamy area with a no. 12 bright. The swath along the bottom is a somewhat lighter, slightly violet mixture of Ultramarine Light, Rose Madder, Titanium White and Raw Umber.

Paint the rock with a no. 8 bright using a combination of Raw Umber, Ultramarine Light and a little Titanium White. Leave the wash showing in areas on the left side where you plan to place your highlight strokes; it also serves as an intermediate color. For the little spot of sand, mix Burnt Sienna, Naples Yellow and Ultramarine Light, and apply it with a no. 12 bright.

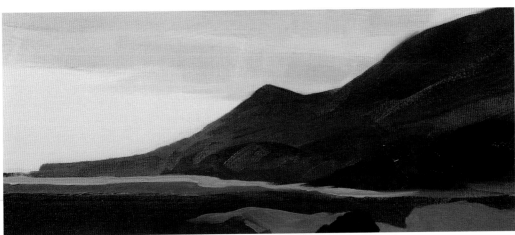

5 Paint the Land Mass and Furthest Water ▶ Strokes 1–5

Suggest the rust-colored cliffs on the left and the lower extension of land with a mixture of Burnt Sienna and Titanium White cooled with a touch of Ultramarine Light. With a no. 8 bright, apply two strokes—one on the far left and one starting in the middle—that wander from left to right.

Combine Ultramarine Light, Raw Umber and Cadmium Yellow Hue into a dark green for the mass of rocks on the far right of the land. Body load a medium amount of pigment onto a no. 12 filbert, then start at the top right of the darkest area and, pressing down on the brush so it spreads out, squiggle the brush around as you work your way left. When you reach the water, ease up a bit and, without lifting the brush, pull to the left and widen the stroke to approximate the shape of the rock; then, narrow the stroke to finish it.

Two horizontal strips of water color—medium and light—lie just below the land. Lighten a little of the gray-green paint you mixed in step 3 with a bit of Titanium White and load a medium amount onto a no. 12 bright. Pulling with the narrow edge of the brush leading the way, paint a strip all the way across the picture. Leave a narrow band of bare canvas between this and the land until you reach the dark rocks. With an even lighter mixture of Titanium White, Ultramarine Light and a touch of Raw Umber, paint a thin band bordering the last stroke and the land.

6 Begin Painting the Middle Waves

▶ **Strokes 6–10**

For the dark of the wave above the rock, mix Phthalo Blue with equal parts Raw Umber and Cadmium Yellow Hue, then apply the paint with a no. 8 filbert. The dark under the curl of the breaker to the left of the rock is the same mixture with a little extra Yellow Ochre added. Lay down a stroke with the same filbert.

Just to the left of that, the green shimmer in the wave is a mixture of Phthalo Blue and Yellow Ochre; apply it with the same brush. Paint a slightly darker blue into the right foaming breaker with a no. 12 bright. Then, chisel load a small amount of a medium-dark mixture of Ultramarine Light, Naples Yellow and Titanium White onto a no. 8 filbert, and sketch in the thin line of shadow defining the bottom edge of the breaker.

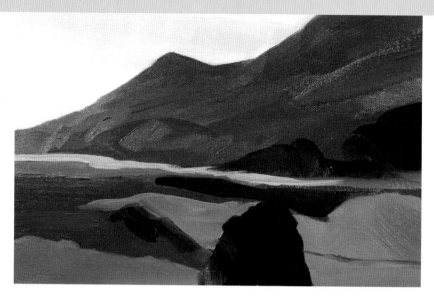

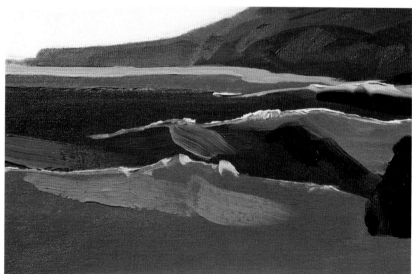

7 Complete the Middle Waves ▶ **Strokes 11–16**

Now you can paint the highlights dancing along the crests of waves to the left of the rock. Chisel load a no. 12 filbert with a mixture of Titanium White and a tiny bit of Ultramarine Light. Pull the brush along the crest of each wave, imitating the shapes of the highlights.

The color for the small foam triangle to the left of that is a mixture of Ultramarine Light, Naples Yellow and Titanium White. Apply the color right through the middle of the green shimmer with a no. 12 filbert.

On the far left in the same band is a slightly lighter series of ripples. Combine Ultramarine Light, Naples Yellow and Titanium White; then body load a medium amount of the pigment onto the same brush, and apply a thick stroke that blends out to the right. To paint the curl of lighter foam on the wave just below that, add Titanium White and Naples Yellow to some of the same mixture. Body load the no. 12 filbert with a fairly large amount of pigment, and apply a thick, long stroke.

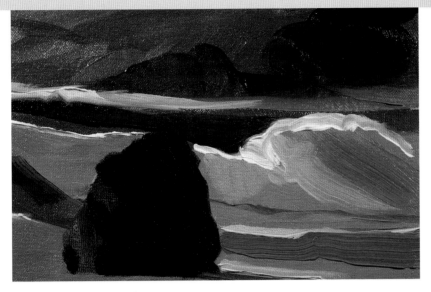

8 *Complete the Right Waves* ▶ Strokes 17–22

To paint the lightest foam atop the right breaker, mix Titanium White with a very small amount of Ultramarine Light and load it onto a no. 8 filbert. Start with a narrow line at the right edge of the rock, then widen it as the wave rises, and drag the paint along the arc of the wave's crest.

A lighter streak angles down the center of the foaming shadow. Mix Titanium White, Ultramarine Light, Phthalo Blue and a touch of Cadmium Yellow Hue, then load up a no. 8 filbert. Start the stroke at the top center and move downward and to the right.

For the shadow of the small wavelet just below your last stroke, combine the same colors but with more blue and less white. Body load a no. 8 bright and thickly lay in the horizontal stroke.

For the wave's highlight above your last stroke, apply a long, narrow, horizontal stroke with a no. 8 bright of a medium-light mixture of Titanium White and Ultramarine Light.

The thin shadow of the rock on the foam is a warmer mixture of Ultramarine Light, Rose Madder and Titanium White. Apply it with a no. 8 filbert. For the highlights above both of the last two strokes, mix Titanium White and Ultramarine Light, then apply the pigment with the same brush.

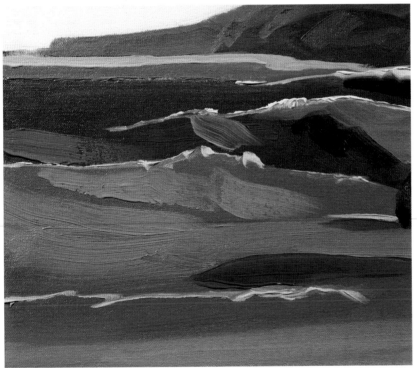

9 *Complete the Left Foamy Area* ▶ Strokes 23-27

Using a 1½" (38mm) house brush loaded with a mixture of Ultramarine Light, Titanium White and Naples Yellow, paint the large area of medium-light foam, pulling it all the way to the base of the rock. For the large shadow near the bottom of the foam and the smaller shadow just left of the rock, combine Ultramarine Light, Yellow Ochre and Titanium White. Apply both strokes with a no. 8 filbert.

Once again, mix up a fairly light hue from Titanium White and Ultramarine Light. Then, chisel load a no. 12 bright and paint the long, irregular highlight sparkling on the lowest wave. Load the same color onto a no. 8 bright and, with one dash, paint the highlight coming from behind the rock.

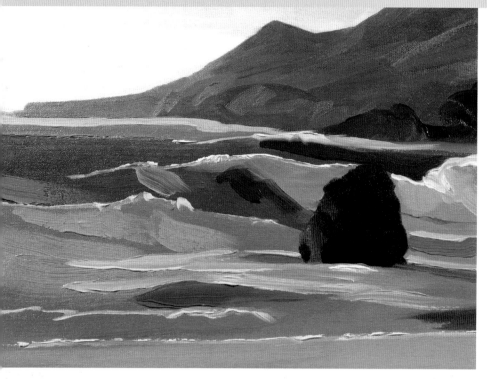

10 *Complete the Foam*
▶ **Strokes 28–31**

Mix up a light combination of Titanium White, Ultramarine Light and Naples Yellow. With a no. 10 bright, apply two long, fairly thick strokes for the light areas in the middle of the foam.

Chisel load a no. 12 bright with the light Titanium White and Ultramarine Light mixture, then paint the light ripple of foam at the bottom by dragging just the tip of the brush along the canvas until you run out of paint.

Also paint the foam highlight in front of the rock with the same light mixture of Titanium White and a touch of Ultramarine Light that you used for the wave crests in step 8. Apply the pigment with a no. 8 bright.

110

11 *Complete the Rock and Shore* ▶ **Strokes 32–35**

For the rock highlights, mix Titanium White with touches of Yellow Ochre and Burnt Sienna. Load the pigment onto a no. 8 bright, and apply the lower highlight as a zigzag of light paint; the upper highlight can be done with one simple stroke. Leave some of the brown wash showing where you want an intermediate hue.

Body load a medium amount of a mixture of Titanium White and Ultramarine Light onto a no. 10 filbert, then apply a long, thick, irregular stroke for the foam highlight just above the sand. The final stroke is a slightly purplish shade in the very lower right corner. Mix Titanium White, Ultramarine Light and Rose Madder, then load the pigment onto a no. 12 bright. Holding the brush at a low angle, pull it from right to left so the paint blends into the lighter color, creating a soft transition with a single stroke.

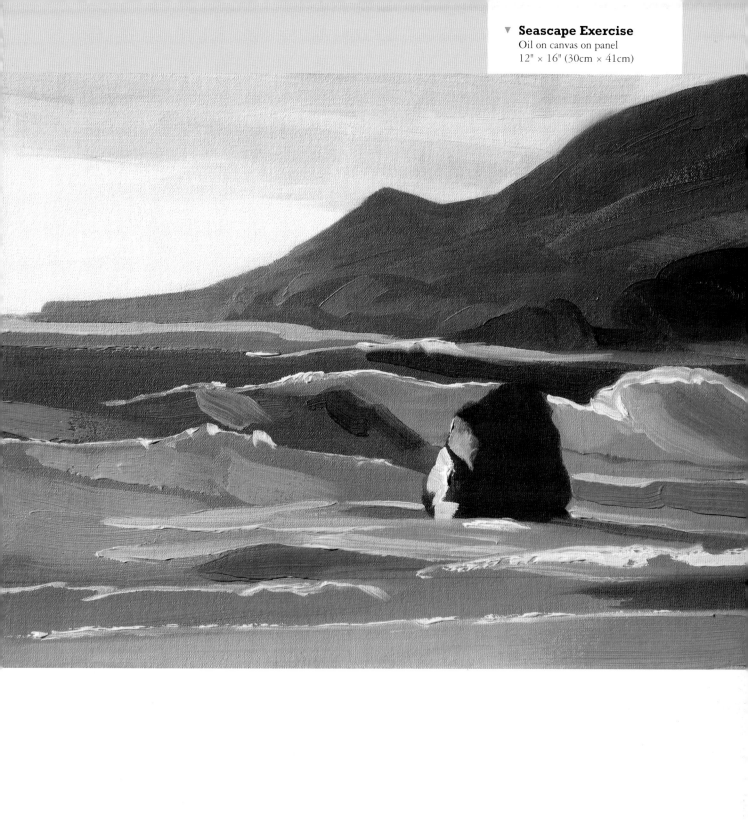

Seascape Exercise
Oil on canvas on panel
12" × 16" (30cm × 41cm)

sunset

You don't need a lot of detail to capture the quiet wonder and rich colors of this sunset. Reduce the most important shapes to rich swaths of pigment, and allow your strokes to blend into one another.

One of the great things about skies is that you can change them. For example, I don't care for the big lump of cloud on the right, so I'm going to change its shape. The land is completely blacked out in the photo, but since I don't care much for the terrain, I'm going to throw in an entirely different landscape. What's the point of being an artist if you can't jazz things up every now and then? Just follow my lead on incorporating a different landscape with the sky and it will work out fine. You might find it necessary to lighten the sky a bit so that it harmonizes with the land.

▶ Materials

Paints *(Holbein Duo Water-Soluble Oils)*

- ► Burnt Sienna
- ► Cadmium Red Hue
- ► Cadmium Yellow Hue
- ► Payne's Grey
- ► Phthalocyanine Blue (Phthalo Blue)
- ► Raw Umber
- ► Rose Madder
- ► Titanium White
- ► Ultramarine Light
- ► Yellow Ochre

Medium

- ► Water-soluble linseed oil

Brushes *(synthetic bristles)*

- ► Bright: nos. 10, 12
- ► Filbert: no. 10

1½" (38mm) house brush *(natural or synthetic)*

▶ Specs

Size: 12" × 16" (30cm × 41cm)

Time for drawing and block-in: 30 minutes

Bold strokes: 25

◄ *Reference Photo*
The things that make this scene appealing are the bright, warm colors and highlights set off by the subtler shadows with the range of soft purples.

▶ the challenge of sunsets

The problem with painting sunsets on location is that the sky changes very rapidly. You have to paint quickly to capture it, not to mention being in the right place at the right time with your painting equipment. On the other hand, one difficulty of painting sunsets from photos is that if you expose the sky properly, the foreground usually comes out terribly underexposed, eliminating all the values, colors and details. You can overcome this by taking multiple exposures at varying shutter speeds. Or, as you'll do in this exercise, you can dub in a completely different landscape.

1 Draw the Scene

With a wash of Cadmium Red Hue thinned with water to #6 consistency, use a no. 10 bright to loosely sketch the large shapes of the clouds and land.

2 Wash In the Landscape

Use a 1½" (38mm) house brush to wash in the landscape with Raw Umber thinned to #6 consistency.

3 Block In the Dark Sky and Mountains

Use a no. 12 bright for all the blocking-in. Leave blank the areas where you intend to place the light yellows in the sky. For the sky color, mix Titanium White, Ultramarine Light and a little Phthalo Blue thinned with linseed oil to #2 consistency. As the sky approaches the top of the lower cloud mass, add a little Titanium White and Rose Madder to both lighten and warm the pigment.

Combine Titanium White, Ultramarine Light, Rose Madder and Payne's Grey for the darkest areas of the top cloud mass. Pull the paint into the sky color so the edges of the cloud blend a little.

For the bottom cloud, combine Ultramarine Light, Titanium White and Rose Madder for the darker sections to the right and left. For the lighter, warmer, central segments, add Cadmium Red Hue, Cadmium Yellow Hue and Titanium White to the previous mixture.

The color of the near mountain is a mixture of Ultramarine Light, Titanium White, Burnt Sienna and Rose Madder. After painting the near mountain, take that color and lighten and warm it with Cadmium Red Hue, Cadmium Yellow Hue and Titanium White, then paint the distant ridge.

4 *Block In the Foreground and Lights in the Sky*

Use the same brush for this step as you did in step 3. The dark foreground is a mixture of Ultramarine Light, Burnt Sienna and Yellow Ochre. Add linseed oil to bring the pigment to a #2 consistency, then loosely block in the terrain with the no. 12 bright. Allow the umber wash to show in places to create horizontal suggestions of bands of dried vegetation.

To make the color of the strip of light sky between the bottom cloud and the land, mix Cadmium Yellow Hue, Rose Madder and Titanium White with a touch of Payne's Grey. Go easy with the Payne's Grey; too much will turn your mixture a greenish hue. Make the strip of sky darker at the extreme right and left.

To create the pale orange of the middle area, combine Titanium White, Cadmium Yellow Hue, Rose Madder and Burnt Sienna.

For the upper left line of light in the cloud, lighten and warm the mixture by adding Titanium White and Rose Madder to the previous combination. Blend the upper edge into the dark shadow as you apply the paint.

5 *Form the Upper Clouds* ▶ Strokes 1–5

For all these strokes, use a no. 10 filbert. Body load the brush with a #2-consistency mixture of Titanium White, Cadmium Yellow Hue and Rose Madder. Apply the long cloud highlight, starting narrowly at the left and gradually widening the stroke by lowering the brush as you move to the right.

For the darker smudge of shadow on the far left, mix Ultramarine Light, Rose Madder, Titanium White and a touch of Yellow Ochre; then body load the brush and apply a meandering stroke that dissipates to the right. Just below that, for the wide stroke of lighter cloud, add Titanium White to the previous mixture along with a bit of Rose Madder and Cadmium Yellow Hue. Apply the stroke going from left to right.

Combine equal amounts of the last two color mixtures and, about six inches to the right, paint a single horizontal cloud shape. To that color, add a little Cadmium Red Hue and paint a narrow reddish dash of cloud between your last two strokes.

6 Build the Central Cloud Mass ▶ Strokes 6–9

Start working on the central cloud by first attacking the medium light on the left. Mix Rose Madder, Yellow Ochre, Ultramarine Light and Titanium White, then make a wide stroke going from right to left with a no. 12 bright.

On the right side of the light yellow, lighten and warm the previous hue with Rose Madder and Cadmium Yellow Hue; then, with the same brush, apply a wide stroke going from left to right.

For the very light yellow splotch in the center, combine Titanium White and a little Cadmium Yellow Hue. With the same brush, start at the edge of the darker clouds with a wide stroke and narrow it a little as you pull up diagonally to the left.

Combine Titanium White with small amounts of Ultramarine Light, Rose Madder and even less Cadmium Yellow Hue to create a light blue for the streak of cloud above the area you just worked on. With a no. 10 filbert, lay down a stroke varying in width, pulling from left to right.

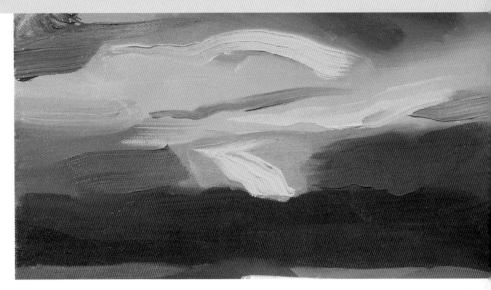

7 Complete the Central Cloud Section ▶ Strokes 10–15

The far right of the main cloud formation is darker. Create a #2-consistency purple-gray by combining Ultramarine Light, Titanium White, Rose Madder and Cadmium Yellow Hue with a little bit of linseed oil. Paint two strokes with the 1½" (38mm) house brush—one wide and angling, the other narrow and more horizontal.

The darker rust-colored long horizontal strip that runs through the center of the main cloud mass is a combination of Rose Madder, Ultramarine Light, Titanium White and Cadmium Yellow Hue. Bring the mixture to #2 consistency; then body load a medium amount of pigment onto a no. 10 filbert and apply a long stroke with a lumpy top edge. (Use the same brush for the remainder of this step.)

There are two orange streaks below that, one slightly lighter than the other. Mix their color from Titanium White, Cadmium Yellow Hue, Rose Madder and a touch of Ultramarine Light; then apply them in long swaths. For the intense orange in the middle of the bottom cloud above the distant mountain, combine Cadmium Yellow Hue and Rose Madder softened with a tiny bit of Titanium White. One quick horizontal dash will do the trick.

8 *Complete the Sky* ▶ Strokes 16–20

It's time to finish the lower right section of the sky, along with some of the land. For all these strokes, thin your paint to #2 consistency.

Create a bright mixture of Titanium White and Cadmium Yellow Hue. Use just the tip of a no. 10 filbert to make a thin line along the bottom of the clouds; then widen the stroke as you move right to paint the broad area where the brightest sunlight glows in the sky.

Next, create an orangish hue from Titanium White, Rose Madder, Cadmium Yellow Hue and Ultramarine Light. Chisel load the same brush, and apply two long, thin strokes on the far right that bracket the darker streak of cloud.

Paint the lower part of the distant mountain darker by making a purplish mixture of Ultramarine Light, Rose Madder, Titanium White and Cadmium Yellow Hue. Load a small amount onto a no. 12 bright, and apply the stroke moving from right to left so the new color blends into the burnt orange color of the peak.

The next nearest mountain on the far right is a gray-green color mixed from Ultramarine Light, Burnt Sienna, Yellow Ochre and Titanium White. Starting at the right edge of the canvas with the same brush, make the stroke as wide as possible; then slightly curve and narrow it to a dagger point at the left where it slices across the distance mountain's base.

9 *Complete the Foreground* ▶ Strokes 21–25

You're ready to wrap up this exercise with a few big strokes—all of them thinned to #3 consistency and applied with a 1½" (38mm) house brush.

First of all, I decided the near mountain should be darker. Create a little darker mixture than the existing color of Ultramarine Light, Titanium White, Burnt Sienna and Rose Madder. Start wide at the right and follow the arched shaped of the mountain, narrowing the stroke as you finish. Leaving some of the original lighter color at the bottom left of the mountain gives it a misty appearance.

The tree is next. It's a dark mixture of Ultramarine Light, Raw Umber and Cadmium Yellow Hue. Apply the stroke from top to bottom with a little widening and wiggle to give it a bit of shape. With the same color, paint a wide stroke along the base of the tree's hill.

For the lighter green of the flat foreground, add Cadmium Yellow Hue to the previous mixture. Make one wide stroke, beginning at the left and streaking right to a narrow, blending conclusion. With the same color, start the final stroke at the left; run along the base of the hill, then angle back up along the hill's slope.

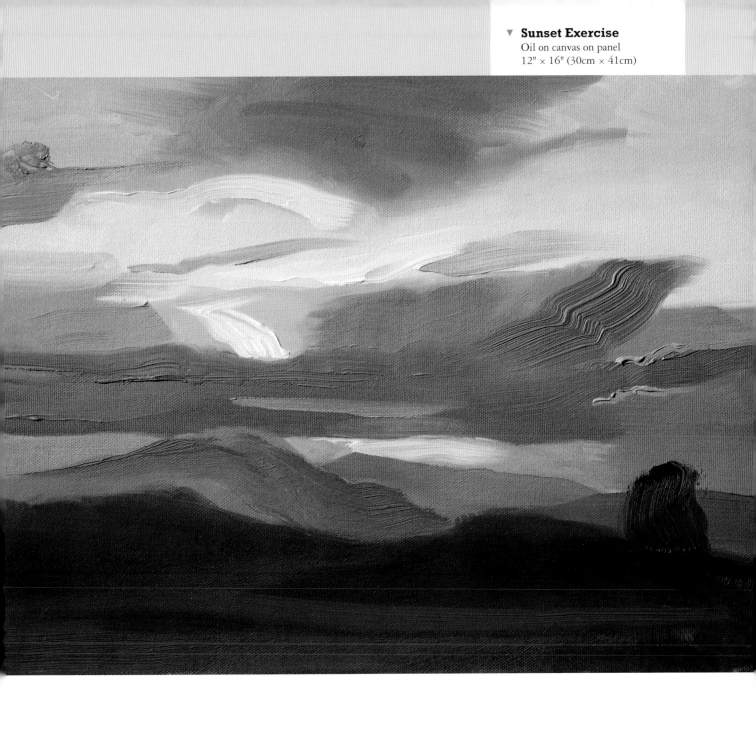

▼ **Sunset Exercise**
Oil on canvas on panel
12" × 16" (30cm × 41cm)

still life

You can take a big sigh of relief now that you're free from the draconian limits on the number of strokes. No more counting! But before you get too carried away with unbridled exuberance, stay focused and avoid falling back into old habits. Build on what you've learned in the previous exercises, and don't rework strokes you've already laid down.

You can improve the overall impact of the image by darkening the shadowed areas of the tablecloth, which will help intensify the highlights of the lace, rose and petal. And cooling the background color will bring out the peachy hue of the rose.

Use your thickest paint application for the highlighted areas of the rose, petal and vase. But especially use thick paint on the brightest areas of the lace to create the texture.

Materials

Paints *(Holbein Duo Water-Soluble Oils)*
- Burnt Sienna
- Cadmium Red Hue
- Cadmium Yellow Hue
- Naples Yellow
- Payne's Grey
- Phthalocyanine Blue (Phthalo Blue)
- Raw Umber
- Rose Madder
- Titanium White
- Ultramarine Light
- Yellow Ochre

Medium
- Water-soluble linseed oil

Brushes *(synthetic bristles)*
- Brights: nos. 6, 8, 10, 12
- Filberts: nos. 4, 6
- Flats: nos. 2, 4

1½" (38mm) house brush *(natural or synthetic)*

Specs

Size: 20" × 16" (51cm × 41cm)

Time for drawing and block-in:
2 hours

Bold strokes: Unlimited

◄ *Reference Photo*
The appearance of the lace in this photo can be loosely captured without rendering all that tedious detail. The rose can be simplified into the main areas of light and dark that define its shapes. The vase is fairly simple and not in need of significant change; just handle the paint loosely.

1 Draw the Subject

Sketch the essential shapes with a no. 10 bright and a wash of Rose Madder thinned with water to #6 consistency. Pay special attention to the vase and the lace pattern, as they are the most crucial elements to get correct.

2 Wash In the Background

Use a 1½" (38mm) house brush and a wash of Raw Umber thinned to #6 consistency to loosely wash in a brownish background that can be allowed to show through in places when you apply the final background color.

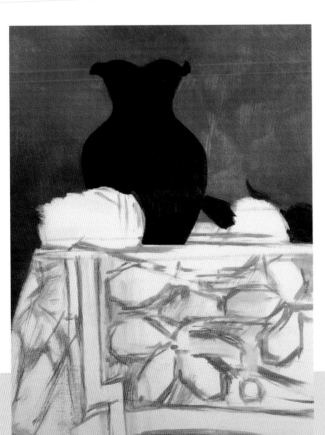

3 Block In the Background, Vase and Leaves

Making the background more of a green-gray will bring out the oranges and reds in the rose.

With a 1½" (38mm) house brush, paint the background with various shadings of Ultramarine Light, Yellow Ochre, Titanium White and Raw Umber. Add a little linseed oil to bring the paint to #2 consistency so it will flow more easily onto the canvas.

The color for the vase is a simple combination of Ultramarine Light and a little Payne's Grey. Paint it with a no. 8 bright. Scrub in the lighter area near the base of the vase with thin paint so it won't be too thick when you apply the lighter color in the next step. The leaves are a mixture of Ultramarine Light, Raw Umber and Cadmium Yellow Hue; paint them with the same brush.

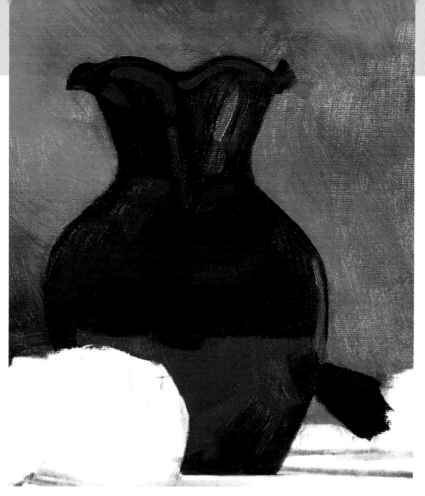

4 Paint the Vase's Intermediate Shapes

Combine Phthalo Blue, Ultramarine Light and Titanium White. Using a no. 6 filbert, paint the light area at the bottom of the vase. With the same brush and a slightly lighter mixture of the same color (with an added touch of Rose Madder to make it a bit more violet), paint the lighter areas. Paint the lights on the vase's right side with an Ultramarine Light and Titanium White combination.

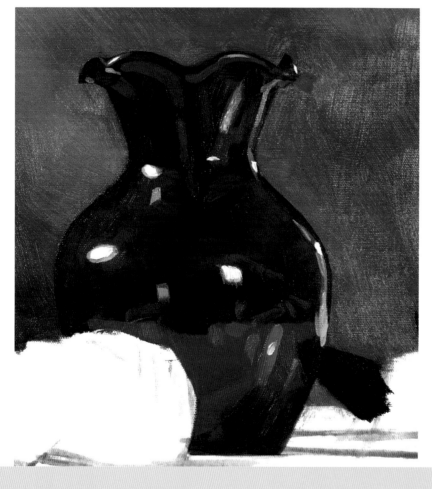

5 Complete Vase Details

Use the same colors you used in the previous step. Apply the finishing strokes with a no. 6 filbert, no. 2 flat and no. 4 flat. Paint the square shapes with the flats and the round shapes with the filbert. For the brightest highlights, paint initial strokes with a medium-light value, then add the final strokes with the lightest paint in a little smaller shape so that you leave some transitional color.

Create a mixture of Titanium White, Yellow Ochre and Rose Madder for the warm light reflection on the right side of the vase.

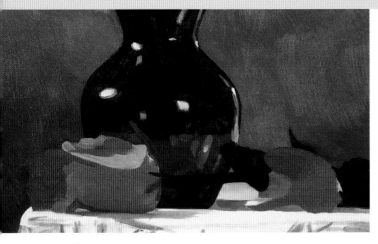

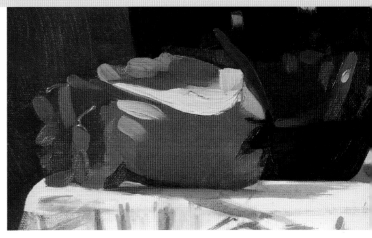

6 *Block In the Rose and Petal*

For the peach hue of the rose and petal, use varying combinations of Rose Madder, Cadmium Yellow Hue, Yellow Ochre and Titanium White. Apply the paint with a no. 8 bright, no. 4 filbert and no. 6 filbert.

Paint the muted white of the tablecloth to the right of the vase with a mixture of Titanium White, Raw Umber and Ultramarine Light with a no. 8 bright. With the same brush and a mixture of Phthalo Blue, Ultramarine Light and Titanium White, paint the rich blue of the vase shadow.

For the leaflet at the base of the rose, mix Ultramarine Light with Cadmium Yellow Hue and lay down the stroke with a no. 4 filbert. Paint the dark stem with a mixture of Ultramarine Light, Raw Umber and Cadmium Yellow Hue using the same brush.

7 *Paint the Rose's Intermediate Shapes*

Use a no. 4 filbert and a no. 6 bright to paint the preparatory strokes on the rose. Use the bright to create square-shaped strokes and the filbert for rounded shapes. Paint the medium-light areas with a combination of Cadmium Yellow Hue, Rose Madder and Titanium White.

For the very lightest petal, body load a mixture of Titanium White, Cadmium Yellow Hue and Cadmium Red Hue onto the no. 4 filbert and lay down a thick stroke. For the yellow-green swath at the base of the rose by the stem, combine Cadmium Yellow Hue, Titanium White and Phthalo Blue; apply it with the no. 6 bright.

On the stem, use Yellow Ochre with just a touch of the previous dark green color. Paint the rust-colored line running down the middle of the stem with a mixture of Burnt Sienna, Yellow Ochre and Raw Umber.

121

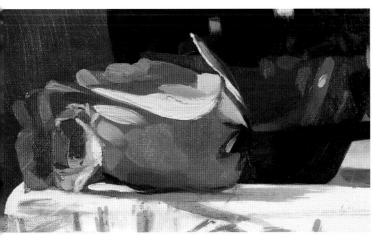

8 *Complete the Rose*

Paint the darkest shadow on the rose where it lays on the tablecloth using a mixture of Raw Umber and Rose Madder with a no. 4 filbert. Lighten the middle of the shadowed body of the rose with a couple strokes of a Cadmium Yellow Hue, Titanium White and Rose Madder mixture applied with a no. 8 bright.

Add a little Burnt Sienna and Raw Umber to your base color for the shadow, and paint the intermediate shadow in the rose along the tablecloth with a no. 4 filbert.

With one deft stroke of a chisel-loaded no. 4 filbert, paint the sliver of light tablecloth under the rose with Titanium White subdued with the slightest touch of Ultramarine Light. Paint the lightest green of the leaflet with a mixture of Titanium White, Cadmium Yellow Hue and Phthalo Blue using a no. 4 filbert.

9 *Paint the Intermediate Shapes of the Petal and Leaves*

Use a no. 6 filbert to apply all the strokes in this step. For the dark areas of the petal, mix Rose Madder, Raw Umber, Yellow Ochre and Titanium White. Combine Titanium White, Phthalo Blue and Yellow Ochre for the light center of the petal. Don't paint over the areas where your very lightest highlights will go.

For the highlight on the tablecloth just to the right of the vase, lay down a couple strokes of Titanium White muted with a tiny bit of Payne's Grey. To paint the lighter green on the right leaves, take the previous dark green and add touches of Ultramarine Light and Titanium White; then apply the strokes with the same brush.

10 *Complete the Petal and Leaves*

For the lighter areas within the petal, combine Cadmium Red Hue and Titanium White; then apply a few quick strokes with a no. 6 filbert. Paint the petal edges with varying light combinations of Titanium White, Cadmium Yellow Hue and Cadmium Red Hue using a no. 8 bright and a no. 4 filbert.

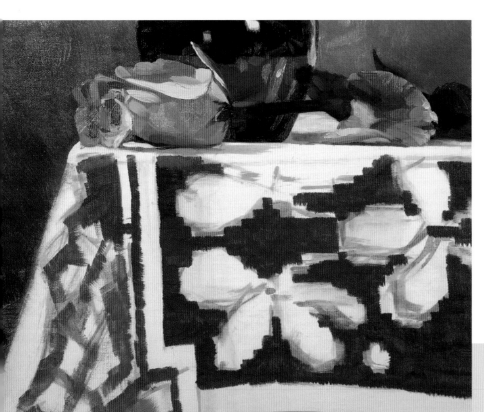

11 *Block In the Darks of the Tablecloth Pattern*

Block in the dark negative shapes of the tablecloth with a mixture of Raw Umber, Ultramarine Light and a touch of Titanium White using a no. 12 bright. On the left side where the negative shapes become lighter and warmer, lighten the color you were using with Yellow Ochre and Titanium White. In all these dark areas, start creating some variations in the pattern with a no. 6 bright.

12 Block In the Lace

To make the highlights of the lace appear even more dazzling, paint the lace in the shadow darker than it is in the reference photo using a mixture of Titanium White, Payne's Grey and Raw Umber. Paint the initial large shapes with a no.12 bright, making them a little darker than you want them to appear in the completed painting because you're going to add light squares for detail.

Using nos. 6 and 8 brights, create an almost digital-looking patchwork of rectangular strokes that vary subtly in value. As the shadowed pattern nears the highlight on the left, add a little Ultramarine Light and Titanium White to the mixture to create a cooler, lighter hue.

Block in the highlighted areas on the left and top of the tablecloth with a medium-light mixture of Titanium White, Yellow Ochre and just a little Ultramarine Light using a no. 8 bright.

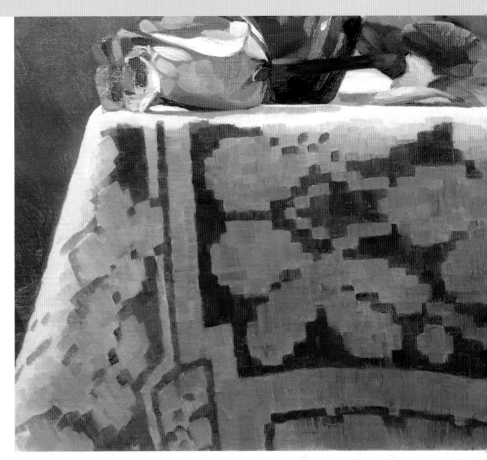

13 Paint Details in the Tablecloth Shadow

Suggest more details of the negative shapes and the lace pattern with a darker mixture of Raw Umber and Ultramarine Light, using a no. 6 bright for the larger rectangles and a no. 2 flat for the smaller squares. You want to get the look of the lace texture without painting all those itty bitty threads. Chisel load paint for most of the smaller strokes.

For the lace itself in the shadow, create even more variations along with warmer spots of light shining through the fold at the left corner. Use varying combinations of Yellow Ochre, Titanium White, Burnt Sienna and Raw Umber applied with a no. 2 flat for those areas.

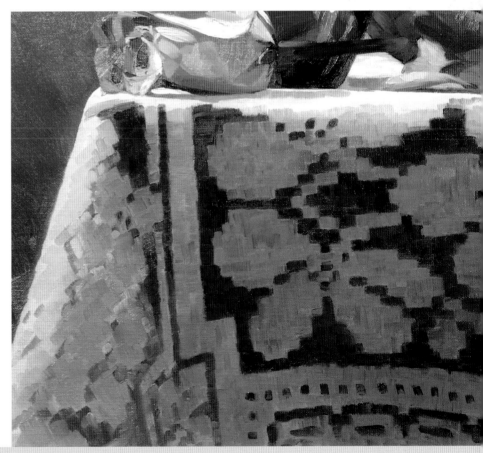

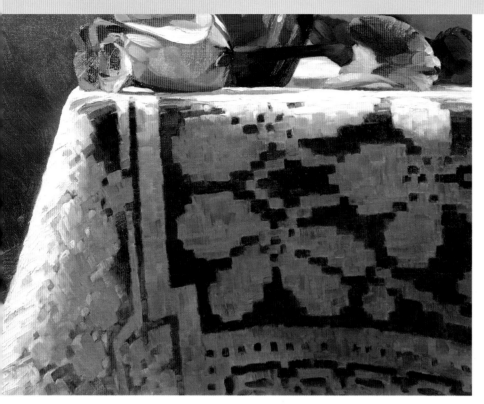

14 Complete the Lace Highlights

Mix Titanium White, Naples Yellow and a touch of Ultramarine Light for the medium highlights on the lace, and apply them with a no. 4 filbert.

The final strokes are thick, bright swaths of Titanium White with a slight bit of Naples Yellow body loaded and laid down generously with a no. 4 filbert. Use thick enough paint so that the shadows of the paint body will lend an impression of the lace's texture catching light.

Lace Detail
This close-up shows the thick, loose brushstrokes you can employ to suggest the lace pattern and texture on the brightly lit fold.

drying times vary

The drying time varies for different colors of oil paints. That not only affects when it's practical to overpaint a layer, but also comes into play with a painting like this that has a lot of fast-drying Raw Umber in the darks, and large areas of thick, very slow-drying Titanium White.

You might touch a dark corner of the painting to see if it's dry and conclude it's safe to handle. But even after three or four days, that white will still be wet, and if you accidentally brush against it, you can smear the daylights out of it!

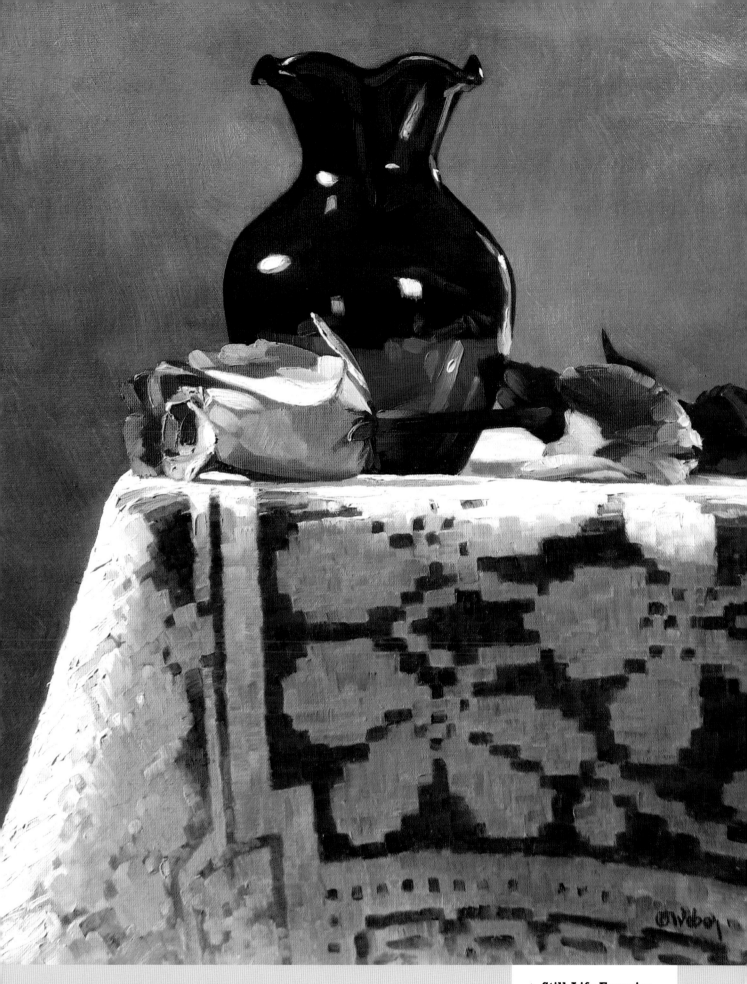

▲ **Still-Life Exercise**
Oil on canvas on panel
20" × 16" (51cm × 41cm)

figure

1 want to conclude with a more advanced image for those of you with more skill or ambition. Because the figure is more difficult than anything you've done up to this point, there is no time limit for the drawing and block-in.

The face can be painted realistically while all else can be done with bold brushwork. That includes the hair, which can be handled very loosely. It will also help to simplify the hand by removing or playing down the veins and tendons. The interesting pattern and colors of the dress present an opportunity to create some loosely painted abstract passages. To accomplish that, though, you'll need to simplify and eliminate details.

Materials

Paints (*Liquitex Heavy Body and Super Heavy Body Acrylics*)

- ▶ Burnt Sienna
- ▶ Cadmium Red Medium Hue
- ▶ Cadmium Yellow Medium Hue
- ▶ Quinacridone Crimson
- ▶ Raw Umber
- ▶ Titanium White
- ▶ Ultramarine Blue
- ▶ Yellow Oxide

Mediums

- ▶ Liquitex Glazing Medium
- ▶ Liquitex Super Heavy Body Gel

Brushes (*synthetic bristles*)

- ▶ Brights: nos. 10, 12
- ▶ Filberts: nos. 4, 6, 8, 10

Brushes (*natural*)

- ▶ Soft-Hair Filberts: nos. 2, 6

1½" (38mm) house brush (*natural or synthetic*)

Specs

Size: 24" × 18" (61cm × 46cm)

Time for drawing and block-in: No limit

Bold strokes: Unlimited

◄ *Reference Photo*
With an image like this, even when using a bold painting approach, accurate drawing is of crucial importance. You can take a good deal of liberty with the dress and background if you are careful with the drawing of the woman's face, and to a lesser extent her hand and arm, and still produce a relatively representational picture.

126

1 *Draw the Figure*

When painting a figure and face, it's far more important to get the proportions and angles correct than it is in a landscape or even a still life, so pay extra attention to your drawing. Remember the measuring techniques you learned in Chapter 3 (pages 45–48).

Create a wash of Burnt Sienna thinned with water to #7 consistency and sketch the basic shapes using a no. 10 bright. When you're ready to do more refined lines, use a no. 6 soft-hair filbert. Because acrylic dries so quickly, if you need to eliminate incorrect lines, you can paint them out with Titanium White. To help you see how the image is developing, wash in some of the crucial shadow areas.

2 *Wash In the Background*

Create a #7-consistency wash of Raw Umber and Titanium White thinned with water and Glazing Medium. Thinning the paint with water alone will disperse the binder too much, but adding medium will increase transparency and help the paint adhere properly to the canvas. Body soak the paint into a 1½" (38mm) house brush and slap it on briskly. At this point, you can't tell how much of this wash you'll want to leave showing through, so do the entire background and the remainder of the dress.

▶ proper placement

Don't be shy about changing your drawing. I move the subject around on the canvas all the time to get it placed just where I want it.

3 *Add a Second Background Wash*

Create a muted greenish hue from Ultramarine Blue, Raw Umber, Yellow Oxide and a bit of Titanium White. To make the mixture translucent, add Super Heavy Body Gel until it constitutes half the total mass of paint, then add a little water. Wait until the first wash is dry; then, working with a no. 10 bright, apply the thick glaze, allowing the original umber wash to show through somewhat.

Normally I'd complete the background at this point, but I'm not yet sure how best to do it, so move forward on the figure. When that's further along, you'll do the finishing work on the background.

4 *Block In the Arms and Wash In the Dress*

In order to work on the arms wet-into-wet, mix up the basic colors you'll need before you begin painting, then mist the paint regularly and paint one section at a time. Lay in the large areas with a no. 12 bright, and use a no. 8 filbert for smaller strokes.

Start by mixing three values of the flesh color from Titanium White, Quinacridone Crimson, Ultramarine Blue, Cadmium Red Medium Hue, Yellow Oxide and Cadmium Yellow Medium Hue. From those colors, create a medium hue for the transitional areas, a light color for the most strongly lit areas, and a shadow color. The shadows are cooler and need additional Ultramarine Blue and Quinacridone Crimson to shift them slightly toward violet. Because the transitional and light areas are warmer, use more Cadmium Red Medium Hue and Cadmium Yellow Medium Hue or Yellow Oxide.

Do as much as you can wet-into-wet, but if the paint begins to stiffen, don't hesitate to work wet-on-dry. You'll finish this up in a later step, and do some more glazing, so keep things general at this stage and don't bother painting every nuance.

With a dark mixture of Ultramarine Blue muted with a little Raw Umber, wash in the dress using a no. 12 bright.

5 Block In the Head and Neck

Using the same colors from the previous step, block in the light and dark areas of the face and neck with nos. 4 and 6 filberts. Work wet-into-wet as much as you can.

For the lips, use a glaze of Quinacridone Crimson moderated with a touch of Raw Umber and made transparent with a little Glazing Medium.

With the shadows becoming darker, the hair color suddenly appears very peculiar. Don't panic; the weird hue will resolve itself when you complete the hair.

While you're at it, darken the edges around the face and neck with a mixture of Raw Umber and a little Ultramarine Blue applied with a no. 4 filbert.

6 Paint the Hair

It will be easier to do the hair one section at a time so that the paint remains fluid. Mix Raw Umber with Ultramarine Blue for the dark color of the hair. Mist a section, then paint it with a no. 6 filbert. The two colors are somewhat transparent, so apply the paint thinly or push aside the dark paint with your brush to reveal the Burnt Sienna wash beneath where you want it to look like light strands of hair. Apply the pigment more thickly where you want to create dark shadows.

For the highlights to the left of the cheek and along the crown of the head, add Quinacridone Crimson, Titanium White and Yellow Oxide to your dark mixture. Loosely paint the general shapes with thick, definite strokes.

Close-Up of Hair
The impression of hair can be created with very little work. Scrub the dark paint around so that some areas have thick paint and others have thinner paint, letting the warm wash beneath show through. I've also added a couple of cooler highlights.

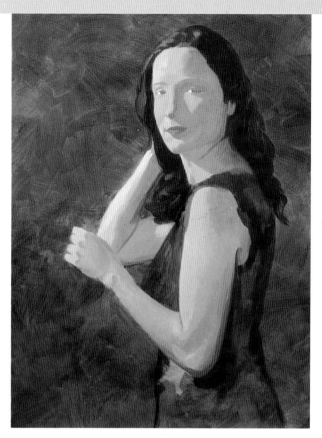

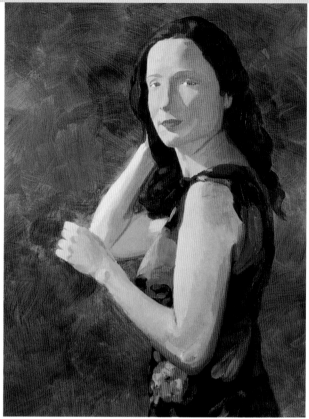

7 Complete the Background

Create a drab olive color by mixing Raw Umber and Ultramarine Blue with touches of Yellow Oxide and Titanium White. The final mixture should contain about fifty percent Super Heavy Body Gel to make it translucent. After misting the canvas, loosely apply the dark glaze with a 1½" (38mm) house brush. Regularly mist the paint as you brush it about to keep it workable.

Apply the paint more thickly to the upper half of the background to make that area darker. To create lighter areas in the background behind the figure and toward the bottom, brush the pigment out more thinly so more of the underlying lighter color shows through.

mix big piles

When you want to create thick strokes, mix up large piles of paint before you begin. If you make small paint piles, you won't have enough pigment to load for a satisfactorily thick stroke.

8 Paint the Dress

The fun of painting the dress lies in its variety of rich colors. Mix up many of these beforehand to make it easier to work wet-into-wet. The dark of the dress is a mixture of Ultramarine Blue, Raw Umber and a little Titanium White. To make the dress purple in some areas, add Quinacridone Crimson and more Ultramarine Blue. Mix two or three values of the peach color from varying proportions of Quinacridone Crimson, Cadmium Yellow Medium Hue and Titanium White; for darker sections, add Ultramarine Blue.

The turquoise is a mixture of Ultramarine Blue, Titanium White and Yellow Oxide. Combine Cadmium Yellow Medium Hue and Cadmium Red Medium Hue for the dash of orange above the shoulder. For the spots of green, add Yellow Oxide to the turquoise. Paint everything with a no. 10 filbert, applying the pigment thickly and boldly.

For the mauve sections on the lower right of the dress, mix Quinacridone Crimson, Ultramarine Blue, Titanium White and Raw Umber. Switch to a worn-out no. 6 soft-hair filbert, and apply the paint wet-into-wet with a few splay strokes. Start at the bottom and irregularly smear out the paint as you push the brush upward.

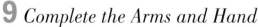

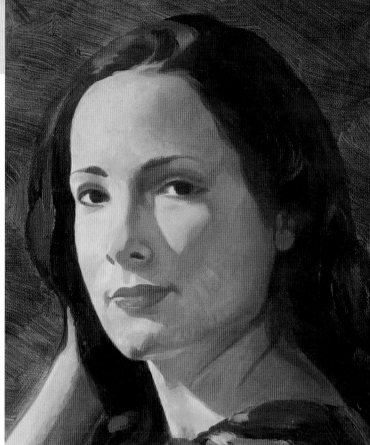

9 *Complete the Arms and Hand*

Use the same colors you used in steps 4–5 to mix the three basic values—light, transitional and shadow. Focus on getting the colors and values just right, and add the degree of loose detail you want. With acrylic it can be difficult to fluidly and loosely paint subtle transitions of color and value in flesh tones. For that reason, paint the transitional areas and especially the shadows with glazes to smooth things out and harmonize colors.

Start with the transitional areas using a no. 6 filbert. Keep the paint moist; while it's still wet, brush in the light areas with opaque pigment, blending the edges of the two bodies of paint.

Since the paint has probably already dried on you, paint wet-on-dry with glazes to make the final adjustments of color and value. Paint the medium-dark shadows with soft glazes using a no. 6 soft-hair filbert. Then glaze in the darkest shadows with the same brush. Keep in mind that the paint will dry darker than it is when wet, so mix it a little lighter than what you think you'll need. Doing the shadows can be challenging, so be patient. If you make a mistake, you can always paint over it.

10 *Develop the Face and Neck*

Darken the face shadows with the same color combination you used for the arms in step 9, and apply the paint with glazes using a no. 6 soft-hair filbert. Use a slightly warmer rendition of the same color for warmer transitional areas like the eyelids and along the nose and chin as well as the folds at the corner of the mouth. Soften the edge of the hair against the face with a glaze of a transitional color.

Warm light is reflecting from the shoulder and neck underneath the chin. Mix a little bit of Cadmium Yellow Medium Hue and Quinacridone Crimson with a touch of Titanium White, and apply a single stroke on the bottom edge of the chin.

For the sections where the light strikes the face, create a medium-light mixture of Titanium White, Quinacridone Crimson and a little Yellow Oxide. Glaze over the lips with Quinacridone Crimson moderated with a minuscule bit of Raw Umber.

Mix Raw Umber and Ultramarine Blue with a tiny bit of Yellow Oxide, and paint the irises using a no. 2 soft-hair filbert. Use the same brush to paint the eyebrows with a lighter mixture of the same color. The whites of the eyes are a mixture of Titanium White, Ultramarine Blue and Raw Umber.

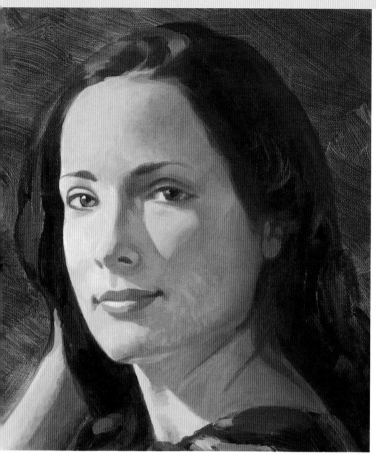

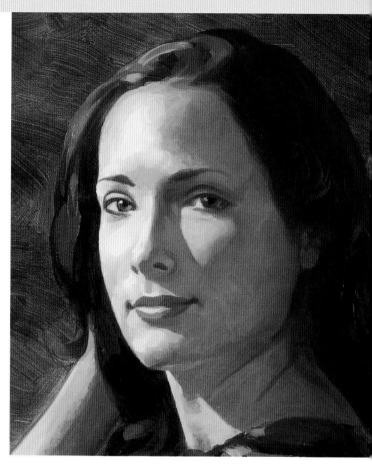

11 *Complete Facial Details*

Do all the work in this step with a no. 2 soft-hair filbert. To finish the lips, mix a medium-light combination of Quinacridone Crimson and Titanium White, then paint the light area of the lower lip with one stroke. Add more Titanium White to the mixture, and paint the lip's highlight with one stroke. Combine Raw Umber, Ultramarine Blue, Quinacridone Crimson and a little Yellow Oxide for the dark in the corners of the mouth, and paint each corner with a single careful stroke.

Paint the dark crease of each upper eyelid with a single stroke of a fairly dark mixture of Raw Umber, Quinacridone Crimson, Ultramarine Blue and a little Titanium White. With the medium-light mixture from step 10, apply a single stroke for the light streak on the woman's right eyelid. Then slightly darken the widest part of the eyebrows.

Make black from Ultramarine Blue and Raw Umber to paint the pupils. Then, with a very small amount of Titanium White and Ultramarine Blue, paint the sparkles in the woman's eyes. The sparkle in her left eye should be half as bright as that in her right eye. Paint the glow in the iris of her right eye with a touch of Yellow Oxide, Raw Umber and Ultramarine Blue.

12 *Paint the Face and Hair Highlights*

Create a very light mixture of Titanium White with just a touch of Cadmium Yellow Medium Hue and Quinacridone Crimson, then paint the facial highlights with a no. 6 soft-hair filbert. Paint only the brightest areas, and leave the medium-light color you applied in steps 10–11 to serve as a transitional value. There should not be a bright highlight on the woman's left cheek. For the hair highlights above the forehead, apply a few fairly thick strokes of Burnt Sienna mixed with Titanium White and Yellow Oxide using a no. 6 filbert.

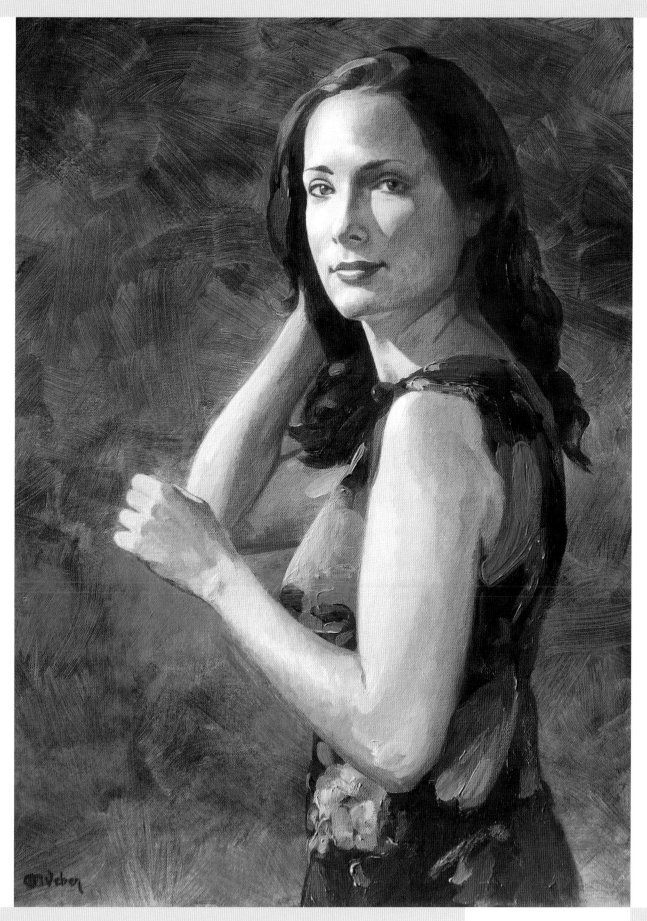

▲ **Figure Exercise**
Acrylic on canvas on panel
24" × 18" (61cm × 46cm)

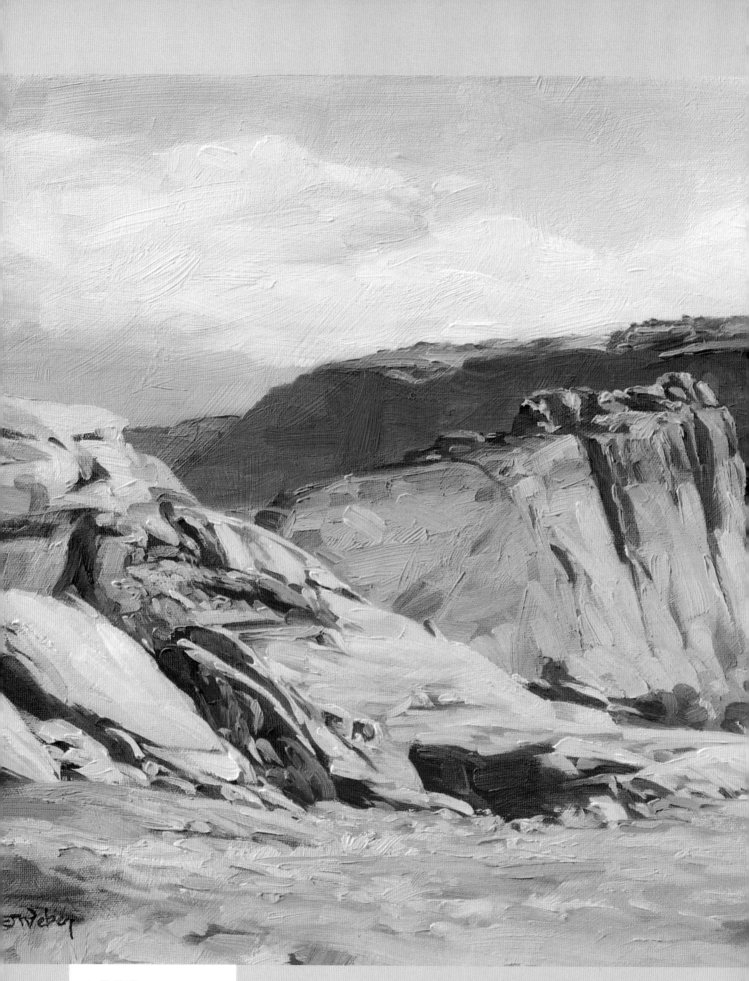

▲ **Fall Canyon**
Oil on canvas
16" × 20" (41cm × 51cm)

ow that you've worked your way through *Bold Strokes*, I'll remind you that this book is focused on training in loose techniques and the thought processes necessary to gain control of your paint and brushes—not a complete guide on how to paint a picture. Keep in mind the exercises are just practice paintings that are not intended to be finished works of art. As you continue to follow these practices, you'll find yourself automatically thinking more concretely about designing your brushwork and about the individual strokes themselves.

The particular stroke choices I've made in the exercises are not the only options for achieving bold brushwork. There are a large number of different approaches that could have been taken. My goal has been to keep things simple and understandable so that you can gain control of thick paint application. Once you do that, a whole world of possibilities

closing word

will open up, and you can go far beyond what I've covered in this slim volume.

In order to keep things manageable, I've steered clear of the practice of painting thick-into-thick. Of course, it's possible to successfully pile thick strokes onto heavy masses of paint and moosh it around; it just takes more skill. First master the mechanics I've covered here, then ease your way into thick-into-thick applications.

You may have experienced a bit of panic when you began the exercises, knowing that you had so few strokes to work with. But that also made you concentrate on what you did with each one. As you move on to painting with as many strokes as you want, leave behind "stroke limit anxiety," but maintain that focus on the mechanics of each stroke.

Continue your development by devising exercises for yourself, using the guidelines I've established. Keep things simple by picking images with clearly defined contrast between light and dark, and avoid images with a lot of subtleties of values, color and blending. This will enable you to master basic principles and techniques that you can apply further down the road to more complex paintings.

As you continue to pursue your adventures in art, let your passion strengthen your discipline, and let beauty and joy guide your passion.

bold brushwork gallery

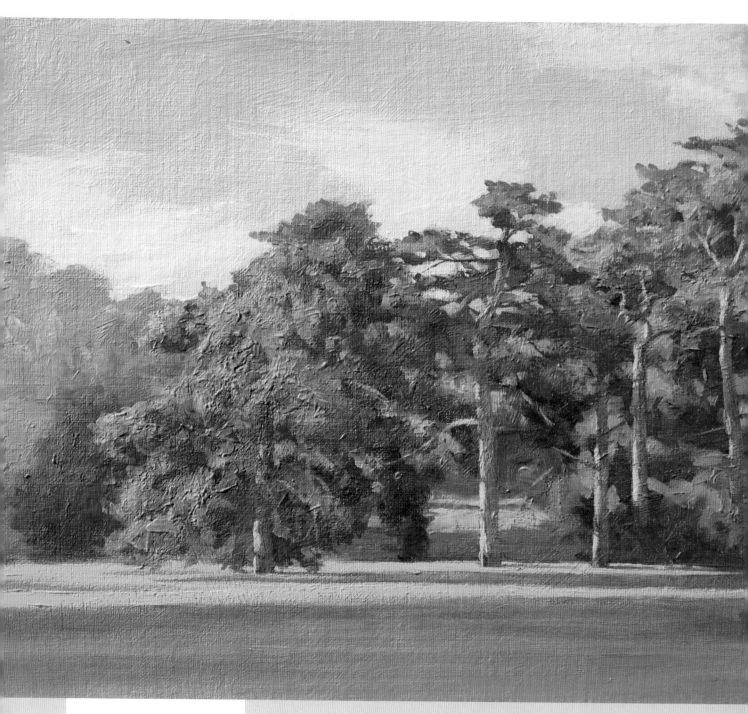

▲ **Grove**
Acrylic on canvas on panel
16" × 23½" (41cm × 60cm)

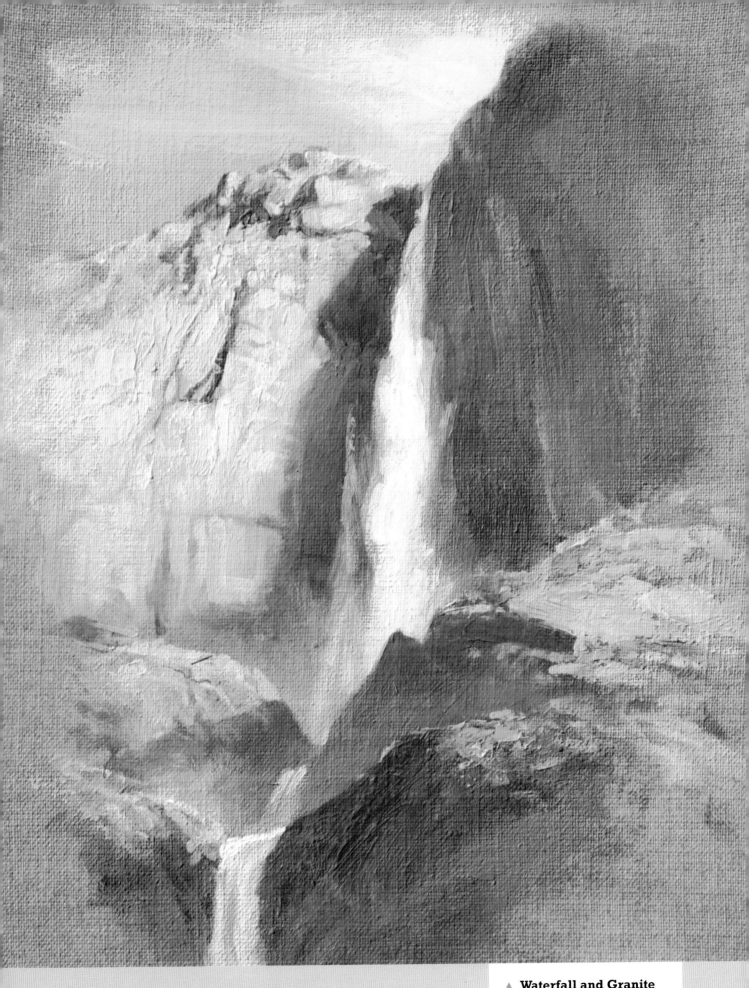

Waterfall and Granite
Acrylic on unprimed linen
17" × 12" (43cm × 30cm)

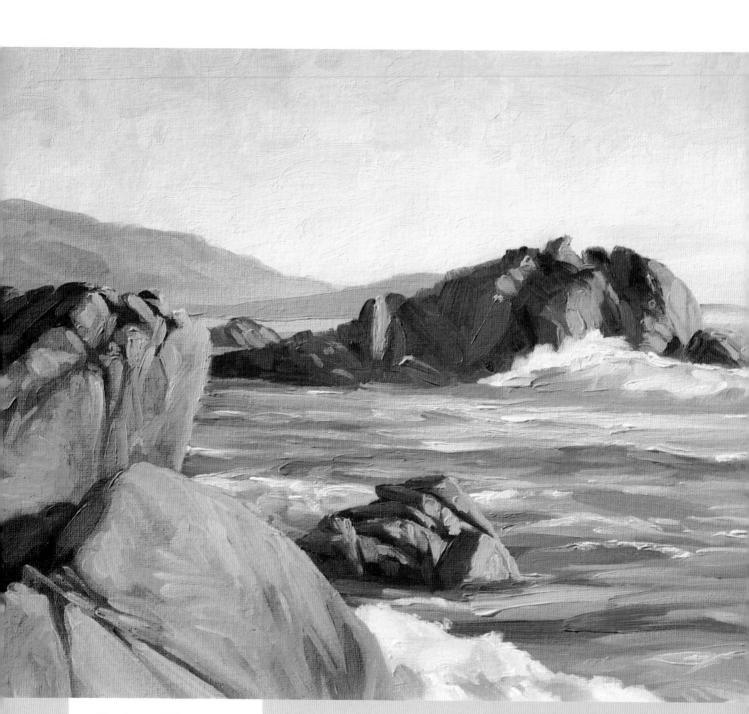

Rocks and Waves
Oil on canvas on panel
14" × 18" (36cm × 46cm)

▲ Gold Cupola
Acrylic on canvas panel
16" × 12" (41cm × 30cm)

Mount Etna Fires
Oil on canvas
9" × 12" (23cm × 30cm)

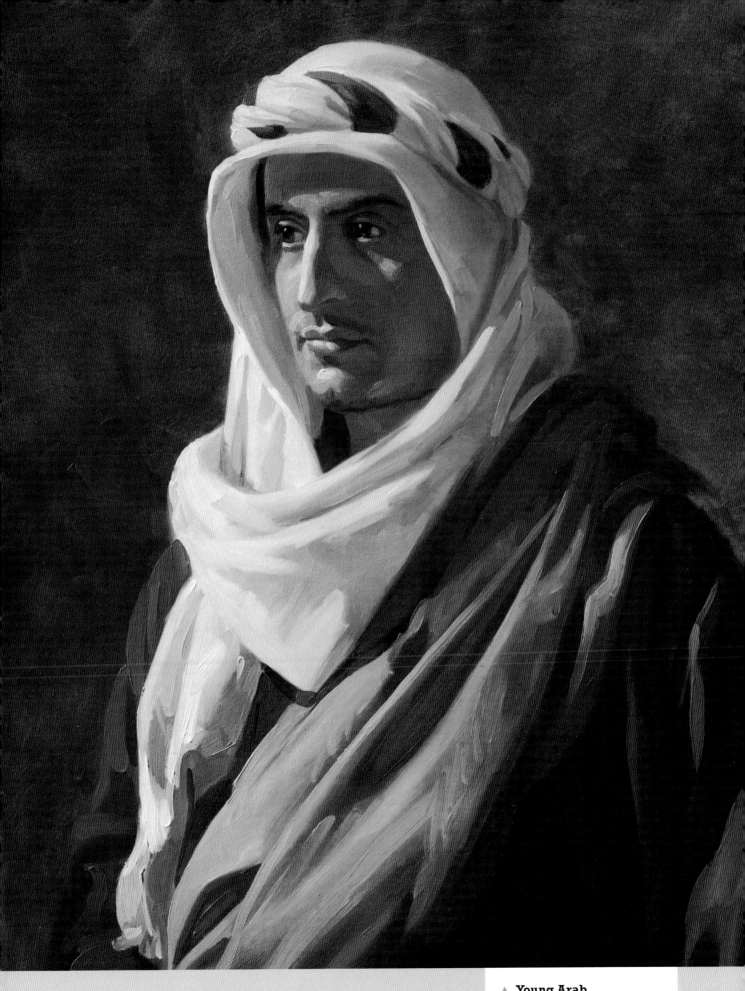

▲ **Young Arab**
Oil on canvas
24" × 18" (61cm × 46cm)

index

The best in fine art instruction and inspiration is from North Light Books!

In this gorgeously illustrated book, Bob Rohm shows you how to see the world from a painterly perspective and translate it into expressive, poetic paintings that elicit an emotional response from your viewer. Learn to clearly illustrate how to choreograph color, value, composition, texture and other fundamental elements to achieve mood and emotion in your landscapes. Features nine step-by-step demonstrations in oil, pastel and acrylic.

ISBN 13: 978-1-58180-998-5
ISBN 10: 1-58180-998-0
HARDCOVER, 144 PAGES, #Z0984

Get ready for the creative ride of your life! Tradition is out, experimentation is in with this cutting-edge how-to sampler of inventive, non-traditional, downright inspirational ways to paint with acrylics (pour, scrape, squirt, roll, layer and excavate). Workshop-style instruction covers a wide range of approaches including watermedia effects, subtractive techniques, collage and acrylic skins, acrylic encaustic and creating textures with gels. Studio visits profile 10 artists and their personal approaches to painting with acrylics. If you're itching to try something new, open this book and go for it!

ISBN 13: 978-1-60061-013-4
ISBN 10: 1-60061-013-7
HARDCOVER WITH CONCEALED SPIRAL,
160 PAGES, #Z1060

Whether you're painting sweeping vistas or intimate still lifes, it's the illusion of dimension that pulls viewers in and really makes your paintings pop. This book will teach you the secrets to achieving a convincing sense of depth. Award-winning artist Laurie Humble shares five essential techniques for creating an engaging, push-and-pull dynamic that will enhance your center of interest and give your artwork a realistic, three-dimensional effect. The lessons transcend style and medium, and can be applied to any painting—either from conception or as a way of rescuing a piece that has fallen flat—for results that really stand out.

ISBN 13: 978-1-60061-045-5
ISBN 10: 1-60061-045-5
HARDCOVER, 128 PAGES, #Z1593

These books and other fine North Light titles are available at your local fine art retailer, bookstore or online suppliers. Also visit our website at www.artistsnetwork.com.